MW01030739

The Cinema of Cruelty

BY THE SAME AUTHOR

What Is Cinema?

Jean Renoir

Charlie Chaplin

Orson Welles

Then French Cinema of
Occupation and Resistance

The Cinema of Cruelty

from Buñuel
to Hitchcock

by **André Bazin**
Edited and with an Introduction by
François Truffaut

Translated by Sabine d'Estrée
with the assistance of Tiffany Fliss

ARCADE PUBLISHING • NEW YORK

English language translation Copyright © 1982, 2013 by Arcade Publishing, Inc.

All Rights Reserved. No part of this book may be reproduced in any manner without the express written consent of the publisher, except in the case of brief excerpts in critical reviews or articles. All inquiries should be addressed to Arcade Publishing, 307 West 36th Street, 11th Floor, New York, NY 10018.

Originally published in 1975 by Editions Flammarion, Paris, France, under the title *Le Cinéma de la Cruauté*

Arcade Publishing books may be purchased in bulk at special discounts for sales promotion, corporate gifts, fund-raising, or educational purposes. Special editions can also be created to specifications. For details, contact the Special Sales Department, Arcade Publishing, 307 West 36th Street, 11th Floor, New York, NY 10018 or arcade@skyhorsepublishing.com.

Arcade Publishing® is a registered trademark of Skyhorse Publishing, Inc.®, a Delaware corporation.

Visit our website at www.arcadepub.com.

10 9 8 7 6 5 4 3 2 1

Library of Congress Cataloging-in-Publication Data is available on file.

ISBN: 978-1-61145-690-5

Grateful acknowledgment is made to the following for permission to reprint from previously published material.

Frederick Ungar Publishing Co., Inc., New York: Excerpts from HITCHCOCK: THE FIRST FORTY-FOUR FILMS by Eric Rohmer and Claude Chabrol, translated by Stanley Hochman. Copyright © 1979 by Frederick Ungar Publishing Co., Inc.

Lorrimer Publishers, Ltd., London: "Cruelty and Love in Los Olvidados" by André Bazin, translated by Nicholas Fry, from THE EXTERMINATING ANGEL by Luis Bunuel. Copyright © by Lorrimer Publishers, Ltd.

Cahiers du Cinéma, Paris: "Hitchcock vs. Hitchcock" by André Bazin, translated by Jane Pease and Rose Kaplan, from the English language edition of *Cahiers du Cinéma*, February 1966. Copyright © by *Cahiers du Cinéma*.

Printed in the United States of America

If there is a cinema of cruelty today,
Stroheim invented it. —ANDRÉ BAZIN

Contents

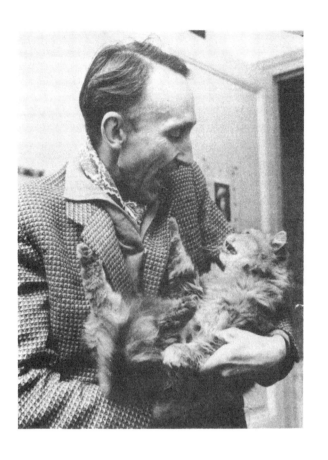

Introduction

André Bazin *was born on April 18, 1918, in Angers, and died at the age of forty. For fifteen years he was the best film critic. It would be more accurate to say the best "writer" about films, since Bazin was more interested in analyzing and describing films than in judging them.*

Bazin studied at La Rochelle, then entered the Ecole Nationale Supérieure in Saint-Cloud in 1938, where he trained to be a teacher. Drafted into the army in 1939, he became more and more interested in film, and in 1942 became one of the founders of the Groupe Cinéma of the Maison des Lettres.* It was at this time

* An organization founded to educate young people whose education had been disrupted by the war.

that he began to write his first articles in student papers (later published as *The Cinema During the Occupation*). After the Liberation he became the film critic of *Le Parisien Libéré, Esprit,* then of *L'Observateur, Radio-Cinéma-Télévision,* and later co-editor-in-chief of *Cahiers du Cinéma.* At the same time, Bazin organized Les Jeunesses Cinématographiques and directed the Cinema Section of Travail et Culture. He presented films at the art theaters and conducted debates with the audience: *La Chambre Noire* and *Objective 48.* Wherever films were shown, Bazin was present. He was a man of films: the most admired, most sought after, as well as the most loved—for he was a strictly moral person who was also tolerant, good, and extraordinarily warm.

In 1948 he got me my first interesting job—it had to do with films. I worked beside him at Travail et Culture, and from then on Bazin became a sort of adoptive father for me. I can truly say that I am indebted to him for everything good that has happened to me since. Bazin taught me how to write. He corrected and published my first articles in *Cahiers du Cinéma,* and he progressively led me toward directing. He died on November 11, 1958; the day before, I had just begun to shoot my first film, *The Four Hundred Blows,* of which he had only seen the script. Naturally, the film was dedicated to him. Shortly before his death he had seen— perhaps for the tenth time—*The Crime of Monsieur Lange* (1935) on television, after which he immediately wrote several pages that comprise one of the best chapters in his posthumously published *Jean Renoir.*

André Bazin, whose goodness was legendary, was

truly a man who antedated Original Sin. Everyone knew him to be honest and generous, but the extent of that honesty and generosity was amazing, and it was constantly lavished not only on friends but also on chance acquaintances. Even an overzealous or abusively bureaucratic policeman was seduced and won over by Bazin after listening to him talk for five minutes. When hearing him speak or argue a point, one witnessed the triumph of right over might.

He had a great heart but was in poor health, which dampened neither his gaiety nor his radiance; Bazin was the embodiment of logic in action, a man of pure reason, and a marvelous dialectician. From the time of his first articles, Bazin called for more mature and responsible film. "No one should be telling us that we need films to suit every taste. At this point, we are far beneath taste. Just the opposite is true: the crisis in films is not really based on an aesthetic level but on an intellectual one. Basically, films suffer from such obvious stupidity that aesthetic quarrels are relegated to the background."

Strongly influenced at the onset of his career by Jean-Paul Sartre, Bazin was, as his friend the critic P. A. Touchard remarked, "a prodigious virtuoso in analysis." His pedagogic sense was widely appreciated. Bazin was, and probably still is, the most translated and published film critic outside France.

When he died in 1958, Bazin left an unfinished manuscript on Jean Renoir, subsequently published in the United States by Simon and Schuster. He had also just finished correcting the proofs of a collection of articles

published in four volumes under the title *What Is Cinema?*, published in America by the University of California Press.

Bazin clearly defined his vocation when he wrote, "The critic's function is not to present a nonexistent truth on a silver platter, but to prolong to the maximum the shock of the work of art on the intelligence and sensibility of his readers."

In this book I have assembled Bazin's writings on six filmmakers who share a very particular style and a subversive way of thinking. Each of them has exercised—or still exercises—a worldwide influence on films. Each film brings out the moralist in the director and makes each of them, beginning with Stroheim, a filmmaker of cruelty.

1. Erich von Stroheim, whose career began as an actor in *The Birth of a Nation* (1915), is an offspring of D. W. Griffith, as are Carl Dreyer, Jean Renoir, and almost all the directors who, starting in 1918, set out to emulate what was best in silent films. Stroheim, who made only nine films and had to give up directing after the advent of sound (with one brilliant exception), became the symbol of the *cinéma maudit*.

Stroheim, the least elliptical filmmaker in the world, could make two of three traditional exposition scenes last fifty minutes, while his colleagues dealt with such scenes in less than a ten-minute reel. He was a maniacal analyst but never a boring one. In fact, he extended silent scenes with authority, as Marcel Pagnol would later do with talking scenes.

Stroheim was often invited to introduce *The Grand Illusion* (1937) on television—a film in which he had what was probably his best role. But he never managed

to reach the point of how he met Jean Renoir. After a quarter of an hour, he was still bogged down in retelling the story of his train trip to upper Königsberg, where the film was shot, and minutely describing the train conductor's hat, gestures, and so forth.

A passionate naturalist, Stroheim reveled in clichés, but he endowed them with so much reality that they no longer *seemed* clichés. He brought so much humor and self-mockery into his persona of the cynical seducer that each of his films, originating directly from melodrama, transcended cliché to become a kind of sarcastic poem.

2. Carl Dreyer was the filmmaker of whiteness. The religiousness of the themes he chose was an illusion, and it is hard to see the full extent of the subterranean violence in his work or all the pain and anguish that make it succeed. Jean Renoir once said of him: "Dreyer knew Nature better than a naturalist. He knew man better than an anthropologist." Like Renoir himself, Carl Dreyer relied on the sincerity of his characters, whose convictions are often shown to be in violent opposition.

Eleven years separate the production of *Vampyr* and *Day of Wrath;* there was a nine-year hiatus between *Ordet* and *Gertrud;* Carl Dreyer's career was obviously not much easier than Stroheim's. At least he had the satisfaction of practicing his art until his death, which occurred shortly after the Paris premiere of his last film, *Gertrud.*

3. One reason that Preston Sturges is today the least known of the postwar American filmmakers is that his films are rarely shown. Added to this is the arbitrary

nature of the phenomenon of "second-run" films, which, if all goes well, come to their final resting place in one or more national film libraries.

Born in Chicago in 1898, Preston Sturges spent a great deal of his childhood in Paris, and then in Switzerland, before taking up his studies at Janson-de-Sailly. Back in America in the early 1930s, he established a reputation in the theater as a playwright before being called to Hollywood. There, he was a script writer, and became a director in the early forties.

Probably because he began his work during a less carefree time than the prewar period had been, Sturges, following in the steps of Frank Capra, was able to revive American comedy. He shared Capra's social sense, but not his optimism or his idealism. Preston Sturges had a rather mixed career, with resounding flops alternating with smash hits. His most famous films are: *Christmas in July, The Lady Eve, Sullivan's Travels,* and *Unfaithfully Yours.* His last films—one of which, *The Diary of Major Thompson,* was filmed in France—were disasters, and he died soon after. In seeing a film like *Sullivan's Travels* again, we realize Sturges' importance and the originality of a style which dared to mingle comedy with cruelty.

4. After two years of correspondence Buñuel and Bazin finally met at the 1954 Cannes Film Festival. It was a meeting that meant a great deal to both of them. Three years earlier Bazin had written a remarkable analysis of *Los Olvidados.* It was not just a matter of an important film coming out of Mexico, but an event that announced to the world the survival of a filmmaker who had dropped out of sight for twenty years. Buñuel was

the only filmmaker who belonged to the early surrealists. Each of his first two films, *Un Chien Andalou* and *L'Age d'Or,* had created a scandal, after which Buñuel went to America, leaving behind the impression that he had abandoned films.

Both leftists with Catholic upbringings, Bazin and Buñuel took to each other immediately. Their understanding was based not just on their ideas but on a similar way of behaving. Very instinctual and, as he often said, attracted by the irrational, Buñuel was nonetheless fascinated by Bazin's logic and precision, and wanted him to explain and comment on his own work. If many artists, especially in film, are in the habit of mocking or denigrating the secret meanings that critics ascribe to them, this was not the case with Luis Buñuel when he found that Bazin saw him primarily as the moralist that he really was.

The friendly complicity that linked Buñuel and Bazin proves that sometimes a critic can play a positive and complementary role for a director. Here is what Buñuel wrote the day after Bazin's death: "Before I met him, I had been struck by the essay he published in *Esprit* on one of my films. He revealed certain things in my work that I myself was not aware of. How could I not feel grateful to him?

"Afterward, in 1955, we met on the Cannes Festival Jury. His emaciated face and ascetic profile were only a mark imposed upon him by his poor health. But his eyes were kind and smiling. When I came to know him better, I realized his great love of life."

5. The reader may be surprised to find that I have included in this book most of the articles Bazin wrote

on a filmmaker he could never admire completely—Alfred Hitchcock. However, it seemed to me that the inclusion of these articles was both instructive and fascinating. Instructive, because Bazin described Hitchcock's films better than many of his unconditional admirers; fascinating because reading these articles in their order of publication (which was not always the chronological order of the films) shows a kind of resistance that progressively weakened, but lost none of its intransigence. Was Bazin, as we say today, "allergic" to Hitchcock? No. But it goes without saying that Bazin's generosity made him lean more toward Renoir, who loved people, than toward Hitchcock, who loved *only film.*

Stroheim was not a real cynic; he was motivated by cynicism that belied a strong sentimentality, which was held in check by humor. Buñuel points out the aberrant behavior of his contemporaries with a derisive laugh, but he *does* think that life is worth living. It seems to me that Hitchcock is no less anguished and desperate than Ingmar Bergman, but Hitchcock's pessimism is more secretive, his works lack a certain loftiness of intent that would render them too legible and relegate suspense to the background. If Bazin could have seen *Vertigo, Psycho,* and *Marnie,* I think his feelings about Hitchcock would have become increasingly favorable.

6. This book concludes with a study of Japanese films, in particular those of Akira Kurosawa, who interested Bazin deeply. He was the first to suspect the importance and influence that Kurosawa would exert on the rest of the world. For example *The Magnificent Seven* by

John Sturges is a remake of Kurosawa's *The Seven Samurai*, a film that also prompted Bergman to shoot *The Virgin Spring* in 1959, one of his most famous films. Critics, especially when they are young and fanatical, cannot resist playing the worn-out game of pitting filmmakers against each other. In 1958 *Cahiers du Cinéma* created a controversy over the respective merits of the two greatest Japanese filmmakers, Kurosawa and Mizoguchi. Here is an excerpt from a letter Bazin wrote me at the time, which clearly illustrates his way of thinking.

"I'm sorry I couldn't go with you to see Mizoguchi's films again. . . . I rank him as high as the rest of you do, and I believe I like him even more because I also like Kurosawa, who is the other side of the coin. Can we really know day without knowing night? To hate Kurosawa in order to like Mizoguchi is only the first step toward understanding. Certainly, whoever prefers Kurosawa must be completely blind, but whoever likes only Mizoguchi is one-eyed. In the totality of art there is a contemplative vein and an expressionist vein."

Many of Bazin's texts might still be rearranged and published. Film literature, which is so much more advanced in America than in Europe, has everything to gain by this. When he reviewed *What Is Cinema?* Eric Rohmer wrote, "Let's hope that this series will lead to new volumes, as almost all André Bazin's articles deserve to be published."

—**François Truffaut**

1 Erich von Stroheim

B orn in Vienna in 1885, Stroheim died in 1957. He directed: *Blind Husbands, The Devil's Passkey* (1919); *Foolish Wives* (1921); *Merry Go Round* (1922); *Greed* (1923); *The Merry Widow* (1925); *The Wedding March, The Honeymoon, Queen Kelly* (1928); and *Walking Down Broadway* (1933), his only sound film.

Erich von Stroheim
Form, Uniform, and Cruelty

The films of Erich von Stroheim rightfully belong to the critics and filmmakers of the post–World War I period. And his work cannot be well known by anyone who is unfamiliar with the last five years of silent films. Perhaps because it is more recent than that of Chaplin and Griffith, his work needs some time to acquire the objectivity bestowed upon it by retrospectives and historical criticism. Whether by coincidence, accident, or predestination, his films are among the most difficult to view today. His relatively short but brilliant oeuvre exists only in the memories of those who were dazzled by it at the time it was released, and in the respectful admiration they felt for him—an admiration shared by the present generation.

I am not old enough to have seen Stroheim's films when they were first shown, and this means that, when I write about him, I can never compensate for not having been on this cinematic road to Damascus.

We not only lack enough historical perspective and critical documentation to appreciate Stroheim but we are also dealing with a psychological complex unique in the annals of films. A kind of fear, a sacred horror, tacitly relegates him to the Hades of film history. Perhaps that is why it is so difficult to find—among the comments and testimonials of those he most influenced (such as Renoir) or those who most admired him—anything except wild superlatives and value judgments that one would be hard pressed to justify.

We all know how original his subjects and his own character were, as we know that he turned upside down the erotic themes on the screen at a time when Valentino was at the peak of his glory in America while a new art film was emerging in France. We can still glimpse something of these themes in Stroheim-the-actor that we admire today. But nonetheless we must ask ourselves if his importance does not lie in the audacity of his subject matter and the tyrannical violence that is always present in his films. It is therefore fairly difficult to understand the widespread influence he had—an influence which continues today. Because, ultimately, what is admirable about him is precisely the most inimitable portion of his work. If Chaplin has been influential, although less so than Stroheim, his influence comes almost exclusively from word of mouth. In his films when he does not appear as an actor one perceives ultimately the secrets of his style, his stage setting, and direction. Just as Chaplin is at the core of his work,

which cannot be discussed without somehow explaining the character himself, Stroheim cannot remove himself from *Foolish Wives* and *Greed,* in which he has no acting part. If any work in film history, with the exception of Chaplin's, has attained the strictly exclusive expression of its creator, it is that of Erich von Stroheim. That is why studying his work will perhaps allow us to unmask a false aesthetic problem and resolve a critical paradox.

The paradox is this: an aesthetic revolution involving radical renovation in the formal design of the direction is often only the direct result of an actor's performance, of his basic need to express his inner feelings. The perfect example is still Chaplin. But if we are wrong in thinking that Chaplin invented nothing so far as directing is concerned, and that his film cutting did not involve any particular narrative aesthetic, it is nonetheless true that his importance can be considered to be secondary in this respect. With Chaplin, the actor has almost totally taken over the film. This does not mean, however, that the same holds true for all actors' films. It is simply that Chaplin's style, deriving from music halls and Mack Sennett, had *already* found its full expression in films made *before* Griffith. Editing supplied almost nothing. Another actor might need other resources, and Stroheim, working after *Broken Blossoms* (1919) and *Intolerance* (1916), found it difficult to express himself when faced with the rather strict laws of film editing. It was because of these laws and other formal film practices that Stroheim had to assert himself, just as he did with the scripts of the time.

To explain Stroheim's directing and staging we almost have to resort to an introductory psychoanalysis

of his persona. Let's start by admitting that his work is dominated by sexual obsession and sadism, and that it develops under the aegis of violence and cruelty. The message we must look for in *Greed* or *Foolish Wives,* as in *Intolerance,* is simply of a social or moral thesis. It is a kind of one-track testimonial, a unique and selfsame affirmation of personality, a startling vision of the world seen through a prism colored by consciousness— or rather by the unconscious. For Stroheim, a film was merely the most efficient means of affirming his character and his relationships with others, particularly women. It is worth emphasizing here that Stroheim's message did not have much impact on the literature of his time, nor would it on today's. And it is obvious that Stroheim can be considered tame when compared to the many daring, psychological novels that have been published in the last fifty years. Yet we must refrain from believing that what is conventionally called "subject matter" enjoys, albeit potentially, an existence that is independent of the means of expression that render it perceptible to us. Stroheim would doubtless have been a mediocre writer, but his advent at a certain moment in film history and the actual choice of this particular art form make him equal to the greatest writers. The significance of a theme and the power of a subject are concomitant with the time of their appearance in relation to the history of the art form that sustains them, as well as with the evolution of genres, or styles. If we consider Stroheim as the Marquis de Sade of film, although his novel *Paprika* is not really innovative, the fact remains that the magnitude and originality of a work can, in the final analysis, be measured only by the art form to which it belongs.

Let me stop this aside and return to Stroheim's position in the cinema of his time. Griffith had reinvented films and taught the whole world the laws of editing. De Mille's *The Cheat* (1915) brought about a roughly comparable revolution to film acting. By using either theatrical or simplistic acting, he invented a kind of cinematic syntax to express emotion. After all, Chaplin—as much through his acting as through his narrative style—had taught us the cinematic value of ellipse and allusion. With him, screen artistry attained the sublime by what it did *not* show us. This was also the period when Valentino's erotic bel canto were the rage and when the feminine ideal of the vamp was soon to be imported from Germany. If an attempt is made to synthesize this aesthetic juncture it could be defined, with respect to its basis, by the triumph of the mythological star, crystallizing, as Malraux said, some powerful collective, unconscious instinct. With respect to style, it could be defined by the ultimate implantation of a specific screen language that was basically elliptical and symbolic. Griffith's great discovery was, in effect, having taught the cinema that it was not just capable of *showing* but of *telling;* not just *reproducing,* but *describing.* By analyzing reality through the isolation of a certain fragment outside of its context and by arranging such shots in a certain way in time, the camera was no longer restricted simply to recording a story. It created the story to its own advantage, which could not be simply grasped by photography.

The importance of Griffith and the discovery of editing is immeasurable. And Stroheim's films could not have the same meaning *before* or *after* Griffith. This language had to exist before its destruction could be

called an improvement. But what is certain is that Stroheim's work appeared to be the negation of all the cinematic values of his time. He will return the cinema to its main function; he will have it relearn how to *show*. He assassinated rhetoric and language so that evidence might triumph; on the ashes of the ellipse and symbol, he will create a cinema of hyperbole and reality. Against the sociological myth of the star—an abstract hero, the ectoplasm of collective dreams—he will re-affirm the most peculiar embodiment of the actor, the monstrosity of the individual. If I had to characterize Stroheim's contribution in one phrase, however approximate, I would call it "a revolution of the concrete."

Thus we see that what Stroheim wanted to say on film was the very opposite of what the screen was able to express at that time. An actor to the point of exhibitionism, Stroheim wished first and foremost to show himself. His legendary taste for uniforms is the least important sign of this, yet the most expressive. Around this personality, whose particular originality contained a prodigious will to power, was organized the Stroheimian directing and staging—like concentric circles when a stone is thrown. It goes without saying that Stroheim's genius lies in the fact that his tyrannical pride did not lead him to seek the lion's share of close-ups, as was the foolish conceit of most film stars. If he reigns on screen it was not by the square foot but through the constraint whereby people or things resemble him or submit to his will. One cannot resemble ideas, and one can only reign over people; myths do not suffer when whipped; sadism needs human flesh and nerves; only thus can it triumph over our hearts. This

explains the realism of Stroheim's direction and his use, which was revolutionary at the time, of natural sets, or at least faithfully reconstructed sets that had true dimensions. Orson Welles would later make use of the famous Stroheim ceilings. Stroheim did not ask his actors to convey feelings through acting, according to a vocabulary and syntax of gesture transposed to expressive ends. On the contrary, he asked them to reveal themselves as much as possible, to bare their features without shame. Nothing but the disorder of the human appearance should acquaint the audience with this interior world. Unfortunately, I have seen *Greed* only once. Despite the famous final sequence in the desert, the image that remains engraved in my memory is the unbearably erotic scene at the dentist. Let's not dwell on the Freudian symbol of the tooth that haunts the whole first part of the film, as does all the paraphernalia of the dentist's office that is used as a prelude to love. Since the young woman can no longer bear the pain of the drill, the surgeon puts her to sleep. Only her face emerges from the white cloth that protects her. It is at this point that the man is overwhelmed by uncontrollable desire. There is a kind of sexual fury that Stroheim does not justify by the logic of the situation (a defenseless woman), but by what he shows us of the heroine's face. He literally succeeds in photographing her sleep: we see the slight twitching of her skin, minute muscular movements; the nervous trembling of her lip or eyelid imperceptibly disturb a face on which we read drug-induced troubled dreams. The man's mounting desire (the camera shows us his face with the same indiscretion) is not intimated by the editing or even by his acting. If we participate, ad nauseam, in this scene it

is due to a sort of carnal incantation that emanates from so much physical evidence. Stroheim's actors do not cry glycerine tears. Their eyes are not more of a mirror of the soul than are the pores of a perspiring skin.

Nothing of what I have said up to now would be totally incompatible with a classical conception of staging or directing. Stroheim would be merely an amazing scriptwriter and a director of first-rank actors if the cutting and the forms themselves of the narrative did not corroborate and complete the sense of these working methods. The professional vocabulary of film is unfortunately too poor and ambiguous. The terms "editing" and "cutting" indiscriminately conceal technical or aesthetic realities that are absolutely different. Therefore I must paraphrase, because of my inability to justify personal definitions. Before Stroheim, and even today, in ninety out of one hundred films, the unity of cinematic narrative was, and still remains, the "shot" in Griffith's style—a discontinuous analysis of reality. Stroheim also used close-ups and broke up a scene during the shooting. But the division that he made the event undergo, by force of circumstances, did not stem from the analytical laws of editing. If Stroheim's narrative could not, for obvious technical reasons, escape the discontinuity of shots, at least it was not based upon this discontinuity. But, on the contrary, what he was obviously looking for was the presence in space of simultaneous events and their interdependence on one another—not a logical subordination as with montage, but a physical, sensual, or material event. Stroheim is the creator of a virtually *continuous* cinematic narrative, tending toward permanent integration with all of

space. Unfortunately the technical and aesthetic state of filmmaking at the time prevented him from perfecting this new cutting, for without knowing it, he was inventing what would later become the language of sound films. A "continuous" cutting is in fact inconceivable with a reality in which only visual images can be reproduced, excluding the reality of sound. The absence of sound leaves fatal lacunae in the narrative, lacunae that can only be filled by an appeal to the added symbolism of the acting or the editing. It was necessary to wait for sound and, among other discoveries (or rediscoveries), depth of field before directors could really refine the cutting as Stroheim envisioned it. This is what Renoir did, especially in *The Rules of the Game* (1939), where he managed to dissolve the idea of shots in a reality of liberated space. However, the appearance of sound was necessary to grant Stroheim the place which was rightfully his and which he deserved. He would have been the Griffith of sound films, but his message was only temporarily and partially understood. From time to time in a modern film we find a shot from *Foolish Wives* or *Greed* (for example, the ending of *Manon* by Clouzot, 1949). If there is a cinema of cruelty today, Stroheim invented it. But those who borrow an idea or a situation from him do not always know how to draw their inspiration from his technique. This is because this technique is perhaps more terrifying than his subjects. More professional courage and above all more imagination are needed to be faithful to Stroheim's narrative technique than are needed to draw inspiration from his themes. I can't really think of anyone beside Renoir who knew how to do it; but I also see Orson Welles's sequence shots as a continuation of

Stroheim's narrative style. Almost everything that is really new in film in the last twenty years has some affinity with Stroheim's work. Even today he is largely misunderstood, but his message runs deep, and we keep seeing it resurface here and there. The time has not yet come when sound films cease to be under Griffith's domination and move on to Stroheim and Murnau.

(*Ciné-Club*—April 1949)

Stroheim Lost and Found
(*Dance of Death*)

Those who remember *Greed, Foolish Wives,* and *The Wedding March* know that if films possess a remarkable actor in Stroheim, it is an understatement to say that films lost one of the world's greatest directors—perhaps the greatest after Chaplin. For Stroheim, the roles of actor and director were inseparable. Under the guidance of other directors, Stroheim lost his greatest originality, even as an actor. The character he is usually made to play nowadays is only the shadow of the one that rocked the film world in 1925. It is true that Stroheim had enough character to continue to be an astonishing actor—in spite of this loss of substance. But the fact is that since *The Grand Illusion* he has continued to bury himself in a more and more physically and

morally stereotyped character, one who is opposite of the hero in *Foolish Wives* and *The Wedding March*. Whether playing the part of the international adventurer in *Storm Over Lisbon* (1944) or the Prussian officer in *The Grand Illusion,* Stroheim has obviously become softhearted. Beneath his terrible mask seamed with scars, the shaved head, behind the unsettling silence, behind the brutality with which he drinks a glass of liquor, a repressed and sometimes delicate sensitivity is hidden. And even when entrusted with a "bad guy" role, it never goes very far. The scriptwriter easily gets rid of him through a disgraceful suicide which reveals, in the final analysis, that the villain was not really very dangerous. Frozen in a certain attitude, and displaying the tics of his early roles, Stroheim in reality saw himself dispossessed, by those who used him, of what was the essence of his genius. The former Marquis de Sade of film is today most often only a bogeyman of detective films or a misunderstood softie.

Stroheim's revelation and revolution were the results of unbridled and limitless psychological violence. We undoubtedly owe him the only "imaginative" films in which movies dared to be wholly realistic, where no insidious censorship, however subjective, limited his inventiveness and expression. These films were true to life and as free as dreams. But it would take too long to explain how, motivated only by the desire to dig deeper into his character, Stroheim was also led to invent—like Chaplin—a new aesthetic of direction, whose lessons would be prophetic. But here I only wish to speak of Stroheim the actor.

Unfortunately, several months after the announcement that he would participate in adapting

Dance of Death, very disturbing rumors began to circulate. It was said that Stroheim "added" many things to Strindberg. The film took place twenty years before the time in the play and tongues began to wag that Stroheim was less concerned with being faithful to the play than to giving himself the opportunity to make himself look younger as well as don as many uniforms as possible. Under these conditions, one had every right to fear that the film was, on one hand, a betrayal of Strindberg's work, which was already difficult to adapt and, on the other hand, sanction of the decadence of a man who was naïvely prisoner of his most unbearable bad habits.

Not only is Marcel Cravenne's *Dance of Death* a tour de force of adaptation (in collaboration with Michel Arnaud, dialogue by Jacques-Laurent Bost) but we also are indebted to him for an almost unrecognizable Erich von Stroheim, in that he no longer resembled the artificial image of the last ten years, but looked like himself.

It is certain that without Stroheim as an actor, there would have been no special reason for bringing *Dance of Death* to the screen. His astonishing personality is the focal point of the film. For the first time since *The Grand Illusion,* Stroheim found a role worthy of him and a director who knew how to elicit the best from him. It seems as if Marcel Cravenne, through an intelligent and critical respect for his actor, was able to make his innermost personality reappear. This was not always easy, as Stroheim had his own set ideas. It is unfortunately true that his scenario was indeed set "twenty years earlier." Haunted by the idea of his former persona, Stroheim wanted to recapture it by returning to

the age he was then. Without Stroheim's knowledge, and sometimes by resorting to guile—for example, taking advantage of his actor's fits of temper—Marcel Cravenne was able to egg him on to interpret a role that the latter saw differently. That is why many scenes, which are not in the finished film, had to be shot—to please Stroheim, so that he would agree at another point to act as the director wished. If in art the result only counts, Marcel Cravenne was right, since, because of him or in spite of him, it is really Stroheim whom he gave back to us. Of course, he no longer has the almost unbearable violence shown in *Greed*, but certain scenes, at least fleetingly, contain a flash of blinding cruelty. The famous sword dance in which the old alcoholic officer, who suffers from a heart condition, dances until he drops, is particularly haunting. You must also see him chasing his wife with the tip of his sword in a kind of terrifying and ambiguous banter, or striking her with a whip on the stairway of the castle, to recognize the strange and fascinating uneasiness. He is like a flame in the cinematic hell which he himself created and which twenty years of cinema contrived to forget.

(*L'Ecran français*—June 1948)

2 Carl Theodor Dreyer

B orn in Copenhagen in 1889, Dreyer died in 1968. He directed: *The President, Leaves from Satan's Book* (1919); *The Parson's Widow* (1920); *Love One Another, Once Upon a Time* (1922); *Michael* (1924); *Master of the House, The Bride of Glomsdale* (1925); *The Passion of Joan of Arc* (1928); *Vampyr* (1932), Dreyer's first sound film; *Day of Wrath* (1943); *Two People* (1945); *Ordet* (1954); and *Gertrud* (1964).

The Passion of Joan of Arc

T hose who have the opportunity of seeing Carl Dreyer's masterpiece *The Passion of Joan of Arc* are actually seeing a print made from the original negatives. They were thought to have been destroyed but were miraculously discovered among the out takes of sound film at Gaumont Studios. There is perhaps no other film in which the actual quality of the photography is more important.

The Passion of Joan of Arc was filmed in France in 1928 by the Danish director Carl Dreyer, using French writers and a French crew. Based on a script by Joseph Delteil, the film is in fact inspired by the actual minutes of the trial. But the action here is condensed into one day, conforming to a dramatic requirement that is in no way a distortion.

Dreyer's *Joan of Arc* will remain memorable in film

annals for its bold photography. With the exception of a few shots, the film is almost entirely composed of close-ups, principally of faces. This technique satisfies two apparently contradictory purposes: mysticism and realism. The story of Joan, as Dreyer presents it, is stripped of any anecdotal references. It becomes a pure combat of souls. But this exclusively spiritual tragedy, in which all action comes from within, is fully expressed by the face, a privileged area of communication.

I must explain this further. The actor normally uses his face to express his feelings. Dreyer, however, demanded something more of his actors—more than acting. Seen from very close up, the actor's mask cracks. As the Hungarian critic Béla Balasz wrote, "The camera penetrates every layer of the physiognomy. In addition to the expression one wears, the camera reveals one's true face. Seen from so close up, the human face becomes the document." Herein lies the rich paradox and inexhaustible lesson of this film: that the extreme spiritual purification is freed through the scrupulous realism of the camera as microscope. Dreyer forbade all makeup. The monks' heads are literally shaved. With the film crew in tears, the executioner actually cut Falconetti's hair before leading her to the stake. But this was not an example of real tyranny. We are indebted to Dreyer for his irrefutable translation direct from the soul. Silvain's wart (Cauchon), Jean d'Yd's freckles, and Maurice Schutz's wrinkles are of the same substance as their souls. These things signify more than their acting does. Some twenty years later Bresson resubstantiated this in *Diary of a Country Priest* (1950).

But there is still so much more to say about this film, one of the truest masterpieces of the cinema. I

would like to enumerate two more points. First, Dreyer is perhaps, along with Eisenstein, the only filmmaker whose works equal the dignity, nobility, and powerful elegance found in masterpieces of painting. This is not only because he was inspired by them but essentially because he rediscovered the secret of comparable aesthetic depths. There is no reason to harbor false modesty with respect to films. A Dreyer is the equal of the great painters of the Italian Renaissance or Flemish school. My second observation is that all this film lacks is words. The only thing that has aged is the intrusion of subtitles. Dreyer so regretted not being able to use the still frail sound available in 1928. For those who still think that the cinema lowered itself when it began to have sound, we need only counter with this masterpiece of silent film that is already virtually speaking.

(*Radio-Cinéma*—1952)

Day of Wrath

For the last dozen years or so the name of Carl Dreyer has conjured up little more than a name from film history and art theater showings. His work seemed to come to a standstill at the undefined boundaries of the talking film.

The character of this long silence seemed confirmed by the illness that finally forced Dreyer to be hospitalized. This silence was, however, broken in 1943.

The script of *Day of Wrath* continues in the purest tradition of Scandinavian films. Using very different styles, *The Road to Heaven* (Alf Sjöberg, 1942) and *Ordet* recently demonstrated the permanence of this tradition. This is a somber and cruel story of witchcraft. An aging pastor marries the very young daughter of a supposed witch. The latter thereby benefits from clemency from the ecclesiastic tribunal. The pastor's son, return-

ing to the village, falls of course in love with his step-mother, and she with him. But the mother-in-law, suspecting this sinful love, sets about insidiously to denounce the wife's heritage.

The young woman does seem to possess a strange power: reality bends curiously to her wishes. One night, all she has to do is to wish ardently for her husband's death, and she finds herself free at last. Formally accused of having caused this death by sorcery, she begs her lover to stand by her. But he is too weak and joins the cause espoused by his grandmother and the theologians. In despair, the young widow condemns herself to the stake, refusing to deny her magical powers.

What surprises us from the beginning is the cleverness of the script in which Dreyer simultaneously manages to treat both historical verisimilitude and the rationalist demands of the modern audience. These particular acts of witchcraft can only be coincidences, yet such unsettling ones that it seems quite unlikely that they can be attributed to chance. The heroine's final despair could signify confession as well as a lie. The action profits, then, from a perfect psychological justification as well as a hypothetical, supernatural intervention, and even from an ambiguity maintained on these two dramatic planes. This satisfies our Mediterranean taste for sharpness and simplicity of plot without diminishing the chiaroscuro of the Nordic imagination.

But the true originality of *Day of Wrath* obviously lies in its staging. Intentionally picturesque, it aspires to and attains the style of Flemish painting. Thanks to the skillful lighting and framing, as well as the opposing tones in the costumes (black robes and white ruffs), half the film is a Rembrandt come to life. The sets, in their

subtle sobriety, are sufficiently realistic to avoid the decided abstraction surrounding the faces in *The Passion of Joan of Arc.* Yet they are stylized enough to be not much more than a dramatic and picturesque architecture on which pools of light are accurately distributed.

With its purposefully monotonous rhythm, the cutting relies more effectively on shot composition than on the editing. Dreyer could even be reproached for having extended privation to a kind of poverty level in this film. I am thinking in particular of those short pans where the dizzying rocking motion from left to right replaces the traditional play of shot and countershot. While not questioning the aesthetic of the film itself, one cannot condone the very artificial style of certain exterior sequences and their self-indulgent slowness.

Many of its aspects derive from the tradition of silent films, and *Day of Wrath* uses sound with supreme refinement. The tone and intensity of the dialogue, almost always spoken in whispers, bestow full value upon the slightest nuances: the few cries that tear through this resonant velvet grip us with fear.

The viewer will be more sensitive to the acting. Lisbeth Movin's remarkable face, already distinguished in *The Red Earth,* is decidedly one of the most interesting of the international screen.

The old woman condemned to the stake possesses the moving realism of old age as well as something supernatural that seems to emanate from old age itself. The pastor and his mother are perfect; compared to them, the son seems undefined and rather pale, but his character perhaps implies this malleable weakness.

And yet something does not work in this admirable machine, for how can so much beauty engender so

few feelings, even boredom? Like its contemporary, *Ivan the Terrible* (1942–46), this is not "with it." It is a film simultaneously anachronistic and an ageless masterpiece. Unlike literature, a more evolved art, for example, where the writer can remain faithful to his style and technique throughout his life, the filmmaker does not enjoy the same freedom. It seems that film does not yet have an intrinsic value. Genius in the realm of films must always strive toward the new. However beautiful it might be, any film that does not further the cinema is not wholly worthy of its name. It must mesh with the sensibilities of the viewers in its era. Carl Dreyer is a great director. His work is part of history and nothing will change this state of affairs, not even *Day of Wrath*.

(*L'Ecran français*—1947)

Ordet

The jury at the Venice Festival was reproached for having given *Ordet* a Golden Lion. The film, though very beautiful, was blamed for espousing an out-of-date aesthetic. The jury itself was not happy with its decision as it said that the Golden Lion was being conferred retroactively to the whole of Dreyer's work. This confirmed that *Ordet* did not deserve the supreme honor on its own, but that this honor really did belong to the old Danish craftsman who is gracing Venice by his presence.

Foolish objections and foolish prudence!

God knows, as does the reader, what we really think about the ideas put forth by the avant-garde. We do not only defend films for their intrinsic value but, too often, for the sake of their controversial quality or the richness of their originality. Because they seem to be

conforming to the idea we have of the evolution of cinematic art, we will sometimes praise films which are not as good as others that we damn. In the main, I don't think that we allow ourselves to be seduced by archaic styles or the prolongation of silent expressionism in talking films. But hierarchies in our value system are necessary. Beyond a certain level the notion of obsolescence becomes incongruous. *Ordet* does not show us an "out-of-date" aesthetic—no more than *Limelight* (1952) does.

Such works cannot be evaluated in relation to the evolution of film. They appear from time to time outside any historical frame of reference, like a pearl in an oyster—and the luster of this one is matchless!

There is no longer any doubt that the cinema is equal to any other art form. It is, however, true that rare is the cinematic work that can compete with masterpieces of painting, music, or poetry. But when it comes to a film like *Ordet,* any other name or any title can be mentioned without seeming ridiculous. Dreyer is on a par with the greatest masters.

Ordet (The Word) is an adaptation—probably a very faithful one—of a play by Kaj Munk, a well-known Scandinavian minister and playwright who was killed by the Nazis in 1944.

Ordet was originally written in 1932. The Swedish director Gustaf Molander brought it to the screen about ten years ago. I unfortunately missed it when it ran in Paris, and therefore will not be able to indulge in comparing them. There is definitely something perplexing in the dramatic theme alone. It seems a priori too closely linked to Scandinavian religious mores and customs. But, after all, it isn't linked to these any more

than is Kierkegaard's work—of which we would be reminded even if it were not incidentally referred to in the film.

Let me try to summarize the plot, where daily life is strangely distorted by the ambiguous presence of the supernatural. The action seems to take place about thirty years ago on a prosperous Jutland farm. The old farmer has three children. The eldest, an intelligent and practical character, is married to a lovely young woman who has borne him two daughters and is expecting another baby. But the farmer's youngest son would like to marry the daughter of a village craftsman. The latter is a member of a strict Protestant sect whose tenets clash with those of the farmer. The farmer is a pious man but he favors a joyous Christianity. Their religious rivalry is complicated by a certain social animosity. As for the second son, Johannes, he is a source of anguish to the family. Johannes has returned from the city where he had gone to study theology and become a minister. Now insane, he believes he is Christ and goes around the countryside prophesying. A new misfortune befalls these people. Inger, the young wife, with great difficulty gives birth to a stillborn child. They think she will survive! But Inger dies. The mad son, who had foretold these misfortunes, flees into the night. When it is time to close the casket, Johannes reappears, seemingly cured. He reproaches these people of little faith for not having asked God to bring the dead woman back to life. His youngest niece comes forward to ask for the miracle, and because of this child's faith, Johannes speaks the words of resurrection. I shall leave to the reader the extraordinary suspense of the denouement, which Dreyer prolongs. I will merely say that the ending lives up to the eeriness of the story.

Thinking back on it, the story of Joan of Arc is by no means a commonplace one, either, but it contains the power of a legend as well as historical distance. In *Day of Wrath*, it was fairly easy for Dreyer to have us accept the reality of the beyond in a time when it was so popular. All this kind of help was unavailable to him by the trivial realism of Kaj Munk's play. This most direct and often brutal realism is precisely what he means to express.

In a way, *Ordet* embodies a quasinaturalistic aesthetic. But this harsh dramatic material seems to be illuminated from within by its ultimate reality, and this image is impressed upon my mind by Dreyer's use of light. The staging of *Ordet* is, first of all, a metaphysics of white, that is: a natural progression from gray to pure black. White is the base, the absolute reference point. White is both the color of death and of life. *Ordet,* in a certain way, is the ultimate black-and-white film, the one that says it all.

Within this mother-of-pearl and jet-black architecture, creatures move in perfect harmony, mysteriously and ineluctably. The deliberateness of their gestures, words, and movement only seem slow in retrospect. Here, we have the rhythm of reality itself, as evinced by the wonderful birth sequence, one of the most unbearable moments in world cinema (unbearably beautiful!), in which the doctor's movements accord exactly with the beating pulse of life. But, for Dreyer, this realistic slowness is obviously a consciousness of space and importance of movement. Throughout the film it is tantamount to the importance of whites and grays. Be that as it may, he imposes it on us as an incontestable truth. A quicker movement, for example, that of an animal (as when a cat crosses the

screen in front of Johannes's feet), would seem more incongruous and improbable.

Within this universe, which is more conscious of mystery, the supernatural does not loom up from outside. It is pure immanence, revealed in its extremity as the ambiguity of Nature, and above all the ambiguity of death. Never before in film, and probably very rarely in other arts, has death been approached so closely, both in its reality and its meaning.

Perhaps the themes I have attempted to untangle here are not new in Dreyer's works: it is obvious that *Ordet* logically follows *Vampyr* and *Day of Wrath*.

But I will place it on an even higher level. This is not only because I feel that it reveals Dreyer's art as even more perfect and more internalized but also because the supernatural as it appeared in earlier films was an outgrowth of the profane eeriness that nourished quite a few German and Nordic films. Nothing in *Ordet* is linked to the supernatural. The religious meaning of the word bypasses sensitivity. *Ordet* is a sort of theological tragedy without the least concession to terror.

(*France-Observateur*—1956)

3 Preston Sturges

Born in Chicago in 1898, Sturges died in New York in 1959. A playwright and scriptwriter, he later became a director: *The Great McGinty; Christmas in July* (1940); *Sullivan's Travels, The Lady Eve* (1941); *The Palm Beach Story* (1942); *The Great Moment, The Miracle of Morgan's Creek* (1943); *Hail the Conquering Hero* (1944); *Mad Wednesday* (1946); *Unfaithfully Yours* (1948); *The Beautiful Blonde from Bashful Bend* (1949); *The Diary of Major Thompson* (1956).

Sullivan's Travels

In the months following the Liberation, when the number of American films being shown in France was still relatively low, we were told that Hollywood had—since the time we had lost track of it—been blessed by two sensational directors, Orson Welles and Preston Sturges. Our curiosity is now satisfied. We have seen everything by Welles that is worth seeing. After *Sullivan's Travels, Christmas in July, The Palm Beach Story,* and *The Lady Eve,* we have also been able to recognize Preston Sturges' inspiration as well as talent.

The last three films were not very successful in France. *Christmas in July,* after a good run in Paris, only reached the provinces through art theaters and did not always find a receptive audience there, either. *The Palm Beach Story* and *The Lady Eve* passed by pretty much unnoticed.

If Sturges' originality did not engender the enthusiasm and controversy that Welles's did, it is perhaps because his originality was less majestic and it must undoubtedly have been misunderstood. His scripts and directing seem to continue in the tradition of American comedy, and while they are unquestionably more intellectual, that very aspect renders his humor less accessible to the European public. His extremely slight subjects, pure pretexts for gags and predicaments, did not demand as much thought as Capra's films did. Thus it was hardly noticed that *Christmas in July* showed an important evolution in the specific Hollywood genre known as "American comedy." With its format and its old heroes, American comedy eked out a laborious existence.

Capra was falling with a great crash amid the broken promises of his leanings. From time to time, a "William Powell–Myrna Loy" duo still made us smile a bit, as much at them as at our memories.

In *The Best Years of Our Lives* (1946), when Teresa Wright tells them they were always lucky in love, we missed some of the dialogue between Fredric March and Myrna Loy. They smile, remembering how often they thought they hated each other and had decided to break up. For the American audience, who knew them well, the numerous comedies involving these two actors made them laugh at their constant flirtations with divorce. For us, the war intervened. The Don Juan of comedy, Fredric March, had aged and become a dramatic actor. American comedy had grown old, like its actors, like history.

Preston Sturges is unquestionably the only director who knew how to carry on the genre by in essence reviving it.

Contrary to what it seems, comedy was in reality the most serious genre in Hollywood—in the sense that it reflected, through the comic mode, the deepest moral and social beliefs of American life. It would take too much time here to try to psychoanalyze this, but it's easy to see how the fundamental optimism of a Capra is tied to American capitalism, and how the Cinderella and Prince Charming myth has its modern counterpart in the typist and the boss's son. Through the most zany and diversified gags, an entire concept of the relationship between money, luck, and politics was implicitly implanted in the American consciousness. And it is because the war—at the very least—disturbed the naïveté and unclouded optimism of these myths that American comedy weakened and died like an uprooted tree.

Preston Sturges' genius comes from having made the most of this aging process, basing his humor and the comic principle of his gags on the sociological displacement of the classical comedy.

This shift allows him to present clearly the themes implied in prewar scripts. In *Christmas in July*, for example, the main protagonist is not shown on the screen. It is invisible and all-powerful luck, like God in *Athalie* (Albert Capellani,* 1910). In *The Palm Beach Story*, the incredible wealth of a young lover carries the Prince Charming myth to the point of absurdity. Here, money appears as if in a supersaturated solution, suddenly precipitating the dissolved salt crystals.

In other words, with Sturges, the humor of the American comedy became irony. If he made use of old

* Albert Capellani (1870–1931), a French film director who went to the United States in 1915.

themes it was by forcing them to reveal themselves and thereby to be destroyed.

It remains to be seen if this was the way Preston Sturges pursued a work of social satire or if he was content with the game as it was played. *Sullivan's Travels* seems to answer that question once and for all.

The script is without doubt one of the most sensational ideas imaginable. A great director of American comedies, moved by the human condition, decides henceforth to write about its misery. In order to gather documentary evidence, he disguises himself as a bum and sets out with twenty-five cents in his pocket. The panic-stricken producers have him followed by a specially equipped truck to cater to his creature comforts, should the need arise. Throughout the United States the radio broadcasts daily bulletins on Sullivan's adventures in the land of poverty. After becoming infested with lice in a flophouse and riding a freight train, our scriptwriter returns to Hollywood to turn his dearly acquired "experience" into profit. It is then that an admirable dramatic surprise occurs, abruptly swinging the film in a tragic direction. Sullivan disappears the night that he is to hand out a thousand five-dollar bills to the bums, his "friends," as a publicity stunt for the film company. A train has rolled over a body which is identified as his. All Hollywood mourns its best director.

However, Sullivan has in reality been beaten and robbed by a bum and has a slight case of amnesia. He is sentenced to a few years of hard labor in some Southern state. The convict gang, the prison, and the whip are now a completely new initiation into human misery. On Sundays the convicts with records of good be-

havior are sometimes permitted to watch a film. It is at the movies that Sullivan discovers that laughter is the convicts' only possible escape. When his true identity is known, the great director returns to Hollywood and is entreated to write socially relevant films. Sullivan declares that the best way of being faithful to his adventure is to continue making people laugh.

We can see that such a script, which starts out as an "American comedy" and continues in a realist vein on the *same subject,* constitutes a kind of self-destruction of the genre with which it appears to be connected. But instead of mocking the laws of the genre, Sturges makes their absurdity explode retroactively. If he justifies them in the end, it is only after admitting their untruth and because this untruth is in the end a lesser evil.

Then why does *Sullivan's Travels* leave us unsatisfied? It is because Sturges did not dare—or was not able—to play out the game that he had begun and that he owed us. The tragic interlude does not, for directorial reasons, contain sufficient violence and authenticity. Several commercial conventions still slid in and they contradict the nature of the scenario itself. Since Hollywood was to be contrasted with reality, the script should not have contained anything from Hollywood. The tragedy should have dialectically abolished the comedy and reality should have overwhelmed the film. Only then would the final return to Hollywood have had the ironic character it needed and which would have made the viewer question Sullivan's final wisdom.

As such, however, this film clearly throws light on the meaning of Sturges' work. It has enough merits and takes enough risks for us to consider it one of the most sensational productions of the last ten years. Perhaps

for the first time, Hollywood dared to make a film which satirizes American life. But its shortcomings—as much in the direction as in the script—lead us to believe that Preston Sturges still does not completely deserve his talent.

(*L'Ecran français*—May 1948)

The Miracle of Morgan's Creek

Each of Preston Sturges' films confirms his talent and originality in American productions since 1940. If his films are not as successful in Europe as they should be, it is probably because they are too intimately linked to American manners and customs. Many of their most savory details seem therefore to pass most Europeans by.

It is, however, not necessary to have lived in America to appreciate these films if one has been an attentive viewer of prewar American comedies, for they cannot qualify as comedies of manners in the sense of *Turcaret* and *Topaze*,* for example. Sturges attacks the beliefs,

* *Topaze,* a satirical play (1928) by Marcel Pagnol (1895–1974); *Turcaret,* a comedy of manners (1709) by Alain-René Lesage (1668–1747).

the social superstitions, and the myths that are the embodiment of some typical American ways of life. In *Sullivan's Travels,* he was able to push this to its limit by denouncing the mystification of the cinema, which itself generated the myth. The logic of *The Miracle of Morgan's Creek* is just as unrelenting. Sturges delights in forcing upon his characters—who are totally unfit to deal with these situations—the entire weight of the prejudices, social conventions, and social imperatives that could exist in a small American town in wartime.

By means of the adventures through which he makes his characters travel, we are dismally reminded that bias is no trifling matter. Instead of the standard leading man, his star is a 4-F half-wit. The poor guy finds himself tossed about like a cork on the waves of public opinion—from prison to international fame. I'll let you find out why for yourself.

The characters are literally antiheroes and, as such, are incapable of creating any events themselves, whether good or bad, for which they must suffer the consequences. Make no mistake—this new American comedy is strictly the opposite of what we have seen in the past. Sturges is the anti-Capra. The author of *Mr. Deeds Goes to Town* (1936) made us laugh only to better instill our confidence in the social mythology that his comedies confirm. Sturges' streak of genius comes from having known how to protract American comedy by transforming humor into irony. What I fear is that in this same way he might herald the end of a genre that was, nonetheless, one of the greatest.

(*L'Ecran français*—February 1949)

Hail the
Conquering Hero

It is now quite clear that we must consider Preston Sturges as a moralist. His films have the demonstrative rigor of the "fable," or the didactic tale. The inhumanity of his characters and their lack of psychological complexity, which certain people see as a weakness or a limitation, actually originate from the laws of the comic genre itself. Zadig is not a character but a moral entity, a philosopher's stone which separates base metal from pure clay.

He is certainly one of those moral psychologists whose imaginary characters do not live on ethical truths alone, viz., La Bruyère.

But morality in its pure form has its own history with writings of distinction from the Middle Ages through Anatole France, by way of Voltaire. Why should Sturges be reproached for his inhumanity when

his true purpose is to proclaim collective determinism and the mechanics of society, proving their foolish independence from the human truth to which they refer. All his films are an exploitation of a misunderstanding. What happens when a man is supposed to be lucky (and he believes he is)? You have *Christmas in July.* What happens to a great director when he plays the role of a bum and a bum who is really a writer? You have *Sullivan's Travels.* What does society think of a common convict, a prison escapee who is wanted in a dozen different states, when he passes himself off as the father of sextuplets (who aren't his anyway)? You have *The Miracle at Morgan's Creek.*

Hail the Conquering Hero once again confirms Preston Sturges' harsh method: removing the alibi from the classical and inevitable development of a social predicament that it demands. The viewer, who is in on the secret, can then ascertain that everything takes place exactly as if the hero had in fact won the lottery or a prize or defended a Pacific Island all by himself. In *Hail the Conquering Hero,* we can search in vain for a trace of individual psychology. But Eddie Bracken can't really exist. His character does not define the void in the script that is created by his not being the man he is believed to be—a hero in the Pacific returning to his hometown. The comedy then originates from the fact that society does not perceive that what it glorifies is in fact nothing. Every one of the pseudohero's actions and words continue to raise him in the public's esteem. But the audience feels cheated: when deprived of its alibi, the behavior of society and men appears in all its obscene nakedness of mindless ritual and in its formalism of a liturgy without God. We are watching a curious story of deaf people in which everyone has gone fishing

for the simple reason that everyone thinks that he has gone fishing.

At the risk of repeating myself, I want to stress that Sturges' films protracted American comedy because of its negative message. Frank Capra's *Mr. Smith Goes to Washington* (1939) was to us the incarnation of democratic goodwill and the power of the righteous man in a society designed to let him have the last word. Our compassionate laughter appeases our hearts as it lets us feel its throb. Thus courage, fighting for a good cause, and moral generosity always end up overthrowing the combined forces of evil. Capra illuminates American comedy. His humor derives from a mock irreverence for great principles and from a familiarity with myths. We are told that these great principles are everywhere—the odds are that they can even dance on the head of a Rockefeller's stickpin. Preston Sturges shows us in effect that they are everywhere and surround Americans on all sides. But at the same time he proves that these principles are *only* myths and their power is completely imaginary. He throws them back to the ethic they refer to in sociology: we thought they were at our service and, behold, *they* carry *us* like a cork upon the ocean.

It is not even the film as such that reveals the usurped secrets of his power. To substitute the ludicrous figure of Eddie Bracken for Gary Cooper, James Stewart, or Cary Grant is to prove to us in retrospect that our admiration originates from whatever crushes this hero in spite of himself. The crowd that unwittingly cheers a ghost, attributing to him the marvels of a superman, is our mirror image because it goes to the movies.

You may disagree and say that Preston Sturges was

not too concerned about being a bitter moralist and that almost all his films, beginning with *Hail the Conquering Hero,* do finally reconcile society and is cinema worthy of Capra himself. I concede this, but it is hardly any more important than Molière's denouements. It may be that Sturges was very comfortable in the inner workings of the mythology he preferred to unmask rather than reveal. In this I would willingly see not some dubious social apostolate but, as Alexandre Astruc suggested during the *Objective 49* debate, the tardy revenge of a scriptwriter-turned-director who profits from an excess of power to let off steam. But these hypothetical considerations take nothing away from the objective content or from the consequences of a work that restores to American film a sense of social satire that I find equaled only (due allowances being made) in Chaplin's films.

(*L'Ecran français*—May 1949)

Mad Wednesday

The law of averages seems to rule the movies as mysteriously as it does train accidents. While *Sunset Boulevard* (1950) deliberately takes as its subject the aging actor, *Mad Wednesday* presents us with a disturbing illustration of the same thing in the comic vein. However, we cannot really refer to Billy Wilder's influence on Preston Sturges in this case because although it was shown at the last Cannes Film Festival, *Mad Wednesday* was made in 1946.

In *Mad Wednesday,* we reencounter one of the celebrated comics of the silent era, who was nicknamed "Him" * by all who are old enough to remember. His acrobatic number in *Safety Last* (1923) is one of the high points of burlesque film.

* In France, Harold Lloyd was known as "Lui."

But Harold Lloyd, like Buster Keaton and many other of the great comic stars who came to different degrees directly out of the school of Mack Sennett, had practically disappeared with the advent of talkies. He could have been the main character in *Sunset Boulevard*. In bringing him out of retirement and oblivion, Preston Sturges undoubtedly wished to reacquaint himself with the old burlesque tradition in American comedy. This is so obvious that the film actually begins with a clip of the football game from Harold Lloyd's 1925 success *The Freshman,* which Sturges links purely and simply to his own story.

It has often been said that the quality of the old footage is harmful to the new. I do not find this to be true because it would be misunderstanding the calculated irony of the script. It is a matter of "continuing" the old burlesque tradition, but without the illusion and with the parody. Sturges seems to be saying to us: "Behold the true comic cinema. Judge for yourselves. That's what we should do. Let's try." But art does not repeat itself any more than history does and the director is not taken in by his admiration for Lloyd. In *Sunset Boulevard,* Gloria Swanson exclaims, "Stars don't grow old!" She is right to the extent that the star identifies with the permanent mythology of his or her character. But she is wrong if she believes that her body also originates from this unworldly essence. An actor can grow old and adapt, but the star cannot change in appearance with impunity. That is why the cinematic sky is peopled with burned-out stars. By imagining a script based on the aging Harold Lloyd, Preston Sturges gives him a final reason to exist. But in revealing the physical imprint of time on Lloyd's face—with a distressing and

almost lewd cruelty—Sturges ultimately reduces to ashes the idol whom he had just restored to glory. This film is the most intelligent homage that could be paid to Harold Lloyd and the great school of American comedy. But it seems to be saying to us, "Laugh once again and laugh heartily, but it's the last time—because you're laughing at the death of laughter." Is it just a coincidence that Lloyd's co-star is a lion that has aged a great deal?

(*Radio-Cinéma*—May 1951)

4 Luis Buñuel

B orn in 1900 in Spain, Buñuel directed: *Un Chien Andalou* (1928); *L'Age d'Or* (1930); *Land Without Bread* (1932); *Grand Casino* (1946); *The Great Madcap* (1949); *Los Olvidados* (1950); *Susana* (1950); *Daughter of Deceit, Una Mujer sin Amor; Subida al Cielo* (1951); *The Brute, Wuthering Heights, Robinson Crusoe* (1952); *El, La Ilusión Viaja en Tranvía* (1953); *El Rio y la Muerte* (1954); *The Criminal Life of Archibaldo de la Cruz* (1955); *Death in This Garden* (1956); *Cela s'appelle l'Aurore* (1958); *Nazarin* (1959); *The Fever Reaches El Pao* (1959); *The Young One* (1960); *Viridiana* (1961); *The Exterminating Angel* (1962); *Diary of a Chambermaid* (1964); *Belle de Jour, Simon of the Desert* (1966); *The Milky Way* (1969); *Tristana* (1970); *The Discreet Charm of the Bourgeoisie* (1972); *The Phantom of Liberty* (1974); and *That Obscure Object of Desire* (1977). Buñuel died in Mexico in 1983.

Cruelty and Love in
Los Olvidados

The case of Luis Buñuel is one of the strangest in the history of the cinema. Between 1928 and 1936, Buñuel only made three films, and of these only one— *L'Age d'Or*—was full length; but these three thousand meters of film are in their entirety archive classics, certainly, (with *The Blood of a Poet,* Cocteau, 1930), the least-dated productions of the avant-garde and in any case the only cinematic production of major quality inspired by surrealism. With *Las Hurdes (Land Without Bread),* a "documentary" on the poverty-stricken population of the Las Hurdes region. Buñuel did not reject *Un Chien Andalou;* on the contrary, the objectivity, the soberness of the documentary surpassed the horror and the forcefulness of the fantasy. In the former, the don-

key devoured by bees attained the nobility of a barbaric and Mediterranean myth which is certainly equal to the glamour of the dead donkey on the piano. Thus Buñuel stands out as one of the great names of the cinema at the end of the silent screen and the beginning of sound—one with which only that of Vigo bears comparison—in spite of the sparseness of his output. But after eighteen years Buñuel seemed to have definitely disappeared from the cinema. Death had not claimed him as it had Vigo. We only knew vaguely that he had been swallowed up by the commercial cinema of the New World, where, in order to earn a living, he was doing obscure and second-rate work in Mexico.

And now suddenly we get a film from down there signed Buñuel. Only a B feature, admittedly. A production shot in one month for 45 thousand dollars. But at any rate one in which Buñuel had freedom in the script and direction. And the miracle took place: eighteen years later and five thousand kilometers away, it is still the same, the inimitable Buñuel, a message which remains faithful to *L'Age d'Or* and *Land Without Bread*, a film which lashes the mind like a red-hot iron and leaves one's conscience no opportunity for rest.

The theme is outwardly the same as that which has served as a model for films dealing with delinquent youth ever since *The Road to Life*, the archetype of the genre: the evil effects of poverty and the possibility of reeducation through love, trust, and work. It is important to note the fundamental optimism of this concept. A moral optimism first of all, which follows Rousseau in presupposing the original goodness of man, a paradise of childhood destroyed before its time by the perverted society of adults; but also a social optimism, since it assumes that society can redress the wrong it has

done by making the reeducation center a social microcosm founded on the trust, order, and fraternity of which the delinquent had been unduly deprived, and that this situation is sufficient to return the adolescent to his original innocence. In other words, this form of pedagogy implies not so much a reeducation as an exorcism and a conversion. Its psychological truth, proved by experience, is not its supreme motive. The immutability of scenarios on delinquent youth from *The Road to Life* to *L'Ecole Buissonnière* (the character of the truant) passing via *Le Carrefour des Enfants Perdus*, prove that we are faced with a moral myth, a sort of social parable whose message is intangible.

Now the prime originality of *Los Olvidados* lies in daring to distort the myth. Pedro, a difficult inmate of a reeducation center, a model farm, is subjected to a show of trust—bringing back the change after buying a pack of cigarettes—as was Mustapha in *The Road to Life* buying the sausage. But Pedro does not return to the open cage, not because he prefers to steal the money but because it is stolen from him by Jaíbo, the evil friend. Thus the myth is not denied in essence—it cannot be; if Pedro had betrayed the director's trust, the latter would still have been right to tempt him by goodness. It is objectively much more serious that the experiment is made to fail from the outside and against Pedro's will, since in this way society is saddled with a double responsibility: that of having perverted Pedro and that of having compromised his salvation. It is all very well to build model farms where justice, work, and fraternity reign, but as long as the same society of injustice and pain remains outside, the evil—namely the objective cruelty of the world—remains.

In fact my references to the films on fallen youth

throw light only on the most outward aspect of Buñuel's film, whose fundamental premise is quite different. There is no contradiction between the explicit theme and the deeper themes that I now propose to extract from it. But the first has only the same importance as the subject for a painter; through its conventions (which he only adopts in order to destroy them) the artist aims much higher, at a truth which transcends morality and sociology, at a metaphysical reality—the cruelty of the human condition.

The greatness of this film can be grasped immediately when one has sensed that it never refers to moral categories. There is no Manichaeanism in the characters, their guilt is purely fortuitous—the temporary conjunction of different destinies which meet in them like crossed swords. Undoubtedly, adopting the level of psychology and morality, one could say of Pedro that he is "basically good," that he has a fundamental purity: he is the only one who passes through this mudbath without it sticking to him and penetrating him. But Jaíbo, the villain, though he is vicious and sadistic, cruel and treacherous, does not inspire repugnance but only a kind of horror which is by no means incompatible with love. One is reminded of the heroes of Genet, with the difference that in the author of the *Miracle of the Rose* there is an inversion of values which is not found at all here. These children are beautiful not because they do good or evil, but because they are children even in crime and even in death. Pedro is the brother in childhood of Jaíbo, who betrays him and beats him to death, but they are equal in death, such as in childhood. Their dreams are the measure of their fate. Buñuel achieves the *tour de force* of re-creating two dreams in the worst tradition of Hollywood Freudian surrealism and yet

leaving us palpitating with horror and pity. Pedro has run away from home because his mother refused to give him a scrap of meat which he wanted. He dreams that his mother gets up in the night to offer him a cut of raw and bloody meat, which Jaíbo, hidden under the bed, grabs as she passes. We shall never forget that piece of meat, quivering like a dead octopus as the mother offers it with a Madonna-like smile. Nor shall we ever forget the poor, homeless, mangy dog which passes through Jaíbo's receding consciousness as he lies dying in an empty lot, his forehead wreathed in blood. I am almost inclined to think that Buñuel has given us the only contemporary aesthetic proof of Freudianism. Surrealism used it in too conscious a fashion for one to be surprised at finding in its painting symbols which it put there in the first place. Only *Un Chien Andalou*, *L'Age d'Or*, and *Los Olvidados* present us with the psychoanalytical situations in their profound and irrefragable truth. Whatever the concrete form which Buñuel gives to the dream (and here it is at its most questionable), his images have a pulsating, burning power to move us— the thick blood of the unconscious circulates in them and swamps us, as from an opened artery, with the pulse the mind.

No more than on the children does Buñuel make a value judgment on his adult characters. If they are generally more evil-intentioned, it is because they are more irremediably crystallized, petrified by misfortune. The most horrifying feature of the film is undoubtedly the fact that it dares to show cripples without attracting any sympathy for them. A blind beggar who is stoned by the children gets his revenge in the end by denouncing Jaíbo to the police. A legless cripple who refuses to give them cigarettes is robbed and left on the pavement

a hundred yards away from his cart—but is he any better than his tormentors? In this world where all is poverty, where everyone fights with whatever weapon he can find, no one is basically "worse off than oneself." Even more than being beyond good and evil, one is beyond happiness and pity. The moral sense that certain characters seem to display is basically no more than a form of their fate, a taste for purity and integrity which others do not have. It does not occur to these privileged characters to reproach the others for their "wickedness"; at the most they struggle to defend themselves from it. These beings have no other points of reference than life—this life which we think we have domesticated by means of morality and social order, but which the social disorder of poverty restores to its original essence as a sort of infernal earthly paradise with its exit barred by a fiery sword.

It is absurd to accuse Buñuel of having a perverted taste for cruelty. It is true that he seems to choose situations for their maximum horror content. What could be more atrocious than a child throwing stones at a blind man, if not a blind man taking revenge on a child? Pedro's body, when he has been killed by Jaíbo, is thrown onto a pile of garbage among the dead cats and empty cans, and those who get rid of him in this way—a young girl and her father—are precisely among the few people who wished him well. But the cruelty is not Buñuel's; he restricts himself to revealing it in the world. If he choose the most frightful examples, it is because the real problem is not knowing that happiness exists also, but knowing how far the human condition can go in misfortune; it is plumbing the cruelty of creation. This intention was already visible in the documentary on Las Hurdes. It hardly mattered whether

this miserable tribe was really representative of the poverty of the Spanish peasant or not—no doubt it was—the important thing was that it represented human poverty. Thus, between Paris and Madrid it was possible to reach the limits of human degradation. Not in Tibet, in Alaska or in South Africa, but somewhere in the Pyrenees, men like you and me, heirs of the same civilization, of the same race, had turned into these cretins keeping pigs and eating green cherries, too besotted to brush the flies away from their face. It did not matter that this was an exception, only that it was possible. Buñuel's surrealism is no more than a desire to reach the bases of reality; what does it matter if we lose our breath there like a diver weighted down with lead, who panics when he cannot feel sand underfoot. The fantasy of *Un Chien Andalou* is a descent into the human soul, just as *Land Without Bread* and *Los Olvidados* are explorations of man in society.

But Buñuel's "cruelty" is entirely objective, it is no more than lucidity, and nothing less than pessimism; if pity is excluded from his aesthetic system, it is because it envelops it everywhere. At least this is true of *Los Olvidados*, for in this respect I seem to detect a development since *Land Without Bread*. The documentary on Las Hurdes was tinged with a certain cynicism, a self-satisfaction in its objectivity; the rejection of pity took on the color of an aesthetic provocation. *Los Olvidados*, on the contrary, is a film of love and one which demands love. Nothing is more opposed to "existentialist" pessimism than Buñuel's cruelty. Because it evades nothing, concedes nothing, and dares to dissect reality with surgical obscenity, it can rediscover man in all his greatness and force us, by a sort of Pascalian dialectic, into love and admiration. Paradoxically, the main feel-

ing which emanates from *Land Without Bread* and *Los Olvidados* is one of the unshakable dignity of mankind. In *Land Without Bread*, a mother sits immobile, holding the dead body of her child on her knees, but this peasant face, brutalized by poverty and pain, has all the beauty of a Spanish Pietà: it is disconcerting in its nobility and harmony. Similarly, in *Los Olvidados*, the most hideous faces are still in the image of man. This presence of beauty in the midst of atrocity (and which is by no means only the beauty of atrocity), this perenniality of human nobility in degradation, turns cruelty dialectically into an act of charity and love. And that is why *Los Olvidados* inspires neither sadistic satisfaction nor pharisaical indignation in its audiences.

If I have made passing reference to surrealism, of which Buñuel is historically one of the few valid representatives, it is because it was impossible to avoid this reference. But to conclude, I must underline the fact that it is insufficient. Over and beyond the accidental influences (which have no doubt been fortunate and enriching ones), in Buñuel surrealism is combined with a whole Spanish tradition. The taste for the horrible, the sense of cruelty, the seeking out of the extreme aspects of life, these are also the heritage of Goya, Zurbarán, and Ribera, of a whole tragic sense of humanity which these painters have displayed precisely in expressing the most extreme human degradation—that of war, sickness, poverty, and its rotten accessories. But their cruelty too was no more than the measure of their trust in mankind and in painting.

(Esprit—1951)

Subida al Cielo

It is interesting to note that if Mexican film has re-gained a certain prestige at film festivals in the last ten years and has awakened a new interest among the critics and the public, it is due to a man who represents the exact opposite of the famous Fernández-Figueroa team. Despite the fact that Gabriel Figueroa was Buñuel's cameraman for *Los Olvidados,* the film's success was this time attributed to more than the excellence of cinematography.

The surprise and admiration engendered by Mexican productions right after the war were, unfortunately, short-lived—the feelings stemmed in large part from illusion. It is not surprising that film festival juries on both sides of the iron curtain were conned for two years longer than they should have been—juries seem to

mistake cinema for photography. There was admittedly something more than beautiful photography in *María Candelaria* and even in *La Perla* (both by Emilio Fernández, 1944 and 1945). But it is easy to see, year in and year out, that physical formalism and nationalist rhetoric have replaced realism and authentic poetry. With the exotic surprises gone and Figueroa's cinematographic feats ultimately reduced to fragments of technical bravura, Mexican cinema found itself crossed off the critics' map.

But then a little film, shot in less than three weeks at a cost of 50 thousand dollars, made its entrance. It was made by a director to whom Mexican producers had only entrusted for the past ten years crassly commercial films. With *Subida al Cielo* he obtained a first prize at Cannes, and it is one of the most dazzling successes of the season in Paris. It is entirely thanks to Luis Buñuel that we are talking about Mexican films again.

This filmmaker's case is a strange one, and we lack material as well as psychological information to clarify it. *Subida al Cielo* will not give us a clue. The unity, the constancy of inspiration evinced by the author of *Un Chien Andalou* and *Land Without Bread* is all the more surprising if one considers that it reappears after fifteen years of obscure exile and uncredited commercial works. What seems most astonishing is that in this unexpected resurgence the work should have the freshness of a debut. *Un Chien Andalou*, *L'Age d'Or*, and *Land Without Bread* were well-planned films, lucid and cynical in their refinement. On the other hand, what is striking at first glance in Buñuel's two Mexican films is the constant priority given to poetic design over formal preoc-

cupations, and even over the most elementary logical or psychological credibility. We knew that *Los Olvidados* was shot very quickly and cheaply, which could justify some of the weaknesses, albeit secondary ones, of the script.

But in *Subida al Cielo* neither the element of time nor money could be a clue to Buñuel's incredible contempt for the moral and material verisimilitude of his story. Whittled down to its pretext, it is an absurd provincial melodrama in which two evil brothers attempt, contrary to the wishes of their dying mother, to embezzle their younger brother's share of an inheritance. The young man is forced to abandon his wife on their wedding night to consult with the family attorney—a day's trip away by bus. This, of course, is merely a point of departure. The basis of the film is the trip and the many incidents that delay the arrival of the bus at its destination: a passenger giving birth, the bus mired in mud while attempting to ford a stream, a storm at the peak of the mountain called Subida al Cielo, a young girl's funeral, and, on top of all this, the very Indian remoteness of the busdriver.

But this narrative form has its own logic and construction: we saw it before in *Four Steps in the Clouds* (Alessandro Blasetti, 1942) and now in *Due Soldi di Speranza* (Renato Castellani, 1951). Yet Buñuel doesn't worry about it. The episodes are strung like pearls on the poor-quality thread of a risky metaphor.

Why is it, then, that these criticisms, which should be important, do not really concern the images? The true film lies elsewhere. In the heart of the scenario is a dream sequence, a much longer one than in *Los Olvidados*. The importance of this dream sequence—unques-

tionably the most wonderful we have seen on the screen—is obvious. But we should consider the entire structure of the film as dream-related, the young man's dream as a secondary dream, a dream within a dream. This endless voyage, undertaken to satisfy a mother's wish (her death prematurely interrupts, as if to forbid, the wedding night of her favorite son) is dominated by the obsessive sexual temptation of a too-pretty woman. Her only function is to make the hero fall into adultery before the consummation of his marriage. This journey seems to contain the essential character of these vain, dreamlike pursuits, always too late, or better yet, thwarted by absurd events.

I will not venture to psychoanalyze *Subida al Cielo*. Buñuel's poetry, although visibly born of dreams, does not exclude a free imagination, particularly in this film where we observe for the first time an almost burlesque transposition of his usual themes. The words "freshness," "tenderness," and even "gaiety," which up until now were perfect antonyms for his films, would not be out of place in describing *Subida al Cielo*. The basic themes nonetheless are still there for us to contemplate: a mother's death, infidelity to a young wife, and a child's death.

Here, for the first time, Buñuel's sadism is barely perceptible and at most appears in rare counterpoint (for example, the insignificant but comic character of the man on the stake). One could say that Buñuel, whose pity we saw emerging in *Los Olvidados*, has transcended sadistic asceticism, finally attaining a kind of happiness. But let's not try to describe a man who is, after all, so secretive: there are so few clues and this is such an ambiguous work. Whether it confirms or inval-

idates this hypothesis, we await Buñuel's future works. They belong to one of the rare poets of the screen— perhaps its greatest.

<div align="right">(L'Observateur—August 1952)</div>

Susana

I n a letter he wrote to *Cahiers du Cinéma*, Luis Buñuel, whose *Los Olvidados* enjoyed an unexpected success in Paris, said that he hoped that we in France would also like *Subida al Cielo*. We did! But he was honest enough to say that should we happen to see a film called *Susana the Perverse*, we would not like it. He was right. It would have definitely been better for Buñuel's renewed glory had the distributors not tried to cash in so greedily on the success of two good films by trying to palm off a mediocre one.

But that is the way film merchants are. If the Cannes Film Festival and critical enthusiasm had not brought *Los Olvidados* to their attention, it would have never occurred to them that this film would even be tolerable. Although it is not as engaging a work, *Subida al Cielo* found its small audience thanks to the success of

Los Olvidados. The distributors can therefore only be congratulated on the misunderstanding. *Susana,* on the other hand, is obviously just a commercial production in which Buñuel resigned himself to the most naïve concessions. The staging and direction, hastily polished off on a low budget, cannot totally make up for a script that is conventional to the point of absurdity.

With this in mind, I hope you may derive as much pleasure as I did from this film, which nevertheless hides a minor but definite charm. *Susana* is the opposite of *Los Olvidados* on all counts. First of all, it seems to be based on the most melodramatic commercial moralism. But, to be more precise, it is because the heroine, Susana, has escaped from a reformatory and is presented as incurably depraved. When, at the end, the police catch her and return her to her cell, the scriptwriter flashes back to an idyllic scene on the hacienda, where this demonic female had tried to wreak havoc.

But who, if he is not totally without humor, could take this story seriously? The story is so obviously pushed to the extreme of its conventions that one simply has to make fun of it. This apology for moral order espoused by the lower Mexican nobility at the expense of the "demon of flesh" is too systematic not to undermine its own purpose. Not that I am accusing Buñuel of cynical intentions or that I wish to make *Susana* into an exhibition of black humor—quite the opposite. It is rather a cheery film, as *Subida al Cielo* often was. The problem is not of trying to understand the film from the inside out but to avoid taking it seriously in its intended sense, which is its implied meaning. Immoral because of the excess of its apologue, *Susana* remains immoral without rancor or deep profound convictions. Under

the guise of denunciation, Buñuel *invites* us to laugh with him at a comedy of feminine seduction. The only thing I would have wished for—if not reproached him for—is that he not have restricted himself to trifling with a subject that merits more serious attention. The means of seduction consist of Susana baring her shoulders every three minutes. We cannot even decide if Buñuel speculated on the viewer's frustration. For once he was resolutely working in innocence.

(*L'Observateur*—January 15, 1953)

El

Luis Buñuel's latest film created quite a stir at the 1953 Cannes Film Festival. For most of the audience and the great majority of critics, *El* was merely an alarming melodrama and a frightfully out-of-date undertaking stemming from the worst boulevard theater of 1900. To this drama à la Paul Hervieu,* simplified for film, Arturo de Cordova again used the stale conventions of the Hispanic male star. *Los Olvidados* struck the less sensitive by the obviousness of its cruelty and *Subida al Cielo* by its bizarre imagination, although both films were far from the systematic surrealism of *Un Chien Andalou* and *L'Age d'Or*. What one saw seemed to float incoherently over the conventions of obviously

* Paul Hervieu, playwright (1857–1915). Willpower and force of character dominated his plays. He believed in free will and responsibility with a total lack of religious faith.

facile commercial scripts. Were it not for Buñuel's rather fantastic films that had preceded them, they could have easily passed us by as uninteresting films.

Even in the case of *Los Olvidados,* the most free and personal of all Buñuel's Mexican films, it is easy to dissociate a "social" scenario that is directly imitative of traditional films on juvenile delinquency from the particularly innovative use of detail which constitute its originality.

A doubt, or at least cautious admiration, persists in my mind: To what extent can we really consider an author's flashes of brilliance in a film as accidental, partial, temporary, and perhaps chance successes? a Cartesian criticism, if applied to surrealism, needs to believe in the logic of creation as much as in the consciousness of intent. A perfect example of this is found in *Un Chien Andalou,* but is hard to find in *Susana* or *Subida al Cielo.*

Even less is it to be found in *El.* If Buñuel's preceding films could be explained by his inability to film anything but small commercial scripts for South American crowds, *El,* as much through its casting as through its directing, displays a relatively ambitious technique. With more money this time at his disposal, Luis Buñuel seems mostly concerned with using it to serve the conventions of the worst bourgeois potboilers.

Let the script speak for itself. An excerpt from an advertisement furnished by the French distributor will impartially set it up:

El is the story of a "well-thought-of" man in high society, respected by his friends for his perfect fairness, his high morality, his religious convictions, and his ed-

ucation. Nonetheless, hidden in his very depths is one of the most dreadful of human defects—*jealousy*—in its pure, sick, and obsessive state. This will certainly poison his existence, as it will that of his wife. Her life is a terrible martyrdom. But one day this obsession bordering on madness sets them both free—he enters a monastery and she rediscovers a belated happiness with her former fiancé.

Buñuel has spiced up his story here and there with a few dashes of erotic sadism.

Buñuel was admirably assisted by the acting of Arturo de Cordova and Della Garcès, who is ravishing and wonderful in a difficult role. The cinematography is by Gabriel Figueroa.

I have to admit that I am unclear as to whether this concise recapitulation and these laconic value judgments are to be taken at face value or reflect cold humor. In the last hypothesis, the words fit the movie in the sense that they describe it with the same false objectivity that might give us the key to this strange film.

I will now ask the reader's permission to quote what I wrote the day after *El* was shown at the Cannes Film Festival:

> Reduced for fifteen years to the silence of trivial commercial tasks, imprisoned like the Divine Marquis behind the silver ramparts of American production, and from the depths of his cell where he feigned submission to the rules, Luis Buñuel learned in the flesh of his soul that even symbols and visual accidents are not sufficient alibis for a poet's dreams. The razor blade cannot with impunity open the eye of a world that

clings to blindness. With a terrible humility, he thereby accepted the rules of the game—to kill artists. With appalling humility he deferred to the public and the producers' tastes. . . . *Susana*, scorned by almost all the critics as a minor commercial production, was in fact a rough draft of *El*. Here, the supreme mystification of film through poetry has finally worked itself perfectly into the comfortable setting of a polished film. Like smugglers reduced to swallowing diamonds and retrieving them from their excrement, Luis Buñuel introduces the Marquis de Sade in the style of Paul Hervieu. If, as Georges Sadoul made me see, all the themes from *L'Age d'Or*, barring none, are found in *El*, I must in turn add that there was a bit of Paul Bourget * in *L'Age d'Or* and that bourgeois respectability already limited the imperturbable transit of cartloads of manure. But at that time the irony was explicit and easily decipherable. But shouldn't we rather admire the fact that Buñuel can be deemed as an admirer of liturgy, as a good Christian who at the church door points at us with fingers dampened with holy water! That a bishop kissing a bare foot when washing feet on Holy Thursday should arouse erotic madness in a faithful soul might well be worth his mitered skeleton at the edge of a cliff.

"My madness," says the hero of the film, "is only slight. In the cloister I rediscovered calm and reason." But ten years of this pious serenity have not prevented him from imagining, through the convent walls, the presence of the woman who continues to be the angel of his dreams and whom he does not avow in confession.

"Then, my son," says the father superior, "take up your pious readings again." We hear Buñuel murmur,

* Paul Bourget (1852–1935), author of essays and psychological novels, notably *Le Disciple* (1889).

eyes lowered in the shadow of rough sackcloth, "As you wish, Father."

If I quote at such length from an article I wrote in *Rendez-vous de Cannes*, it is probably because I can no longer recapture the reasons that aroused this enthusiastic exegesis. Not that I renounce it: but since then I have met Buñuel and the reality of the man has intruded itself between his work and myself. The beautiful logic of these calculations has been somewhat disturbed by the knowledge of his concrete psychology. During the last Cannes Festival, Jacques Doniol-Valcroze and I had the pleasant and fascinating privilege of questioning Buñuel at length on his work in Mexico, and in particular on the filming of *El*. We of course asked him if it was wise and justifiable to read between the lines of his film the meanings that we gave it, in particular the kind of interiorized repetition in *L'Age d'Or* that we were not alone to observe. Buñuel replied that he was not conscious of using this repetition and that if it existed, it was involuntary. But he did not find it improbable; he thought that his inspiration must have guided him to do it unconsciously. Nevertheless, when going into detail, Buñuel pointed out many specific meanings in the script and staging which indicated perfectly the duality of his films. Buñuel sees the love scene, during which the manservant raises a cloud of dust with his feather duster, as a way of ridiculing the traditional love scene while apparently respecting its social formality. But, in a more general way, Buñuel, although formally recognizing the unusual and willfully disturbing characteristics of the examples we mentioned, found no conscious explanation for choosing

them other than their comedy, their strangeness, or the simple fact that they came to mind. For example, the husband gets up during the night and looks for an awl, some thread, and a razor blade; he then enters his wife's room with the obvious intention of making her chastity belt more efficient. Buñuel explains that these objects were what his hero had to gather, considering the circumstances and his character, but he recognizes that this choice of objects arises equally from a turn of mind not so much sadistic as "sadist" and inherited from the cult that surrealism dedicated to the Divine Marquis.

Another example of Buñuel's active and creative "unconscious" is quite significant. It is the image that I cited earlier, the one that follows the final rejoinder of the film, "As you wish, Father." After this scene, Arturo de Cordova leaves the cloister garden weaving like a drunkard. Buñuel, it turns out, has no other explanation than that it gave him pleasure to have his actor walk that way.

It therefore seems possible to me, even after Buñuel's personal testimony, to consider *El* as an *oeuvre à clef*. But in any case it is certain that the secret contained in the film was not posited as systematically as a criticism—at least one indifferent to the conscious psychology of creation—one might suspect that it is there because a logical construct is needed. Is this disparity really important? And must the author know what he is doing in order to do it? In my opinion it seems sufficient that Buñuel's testimony, without explicitly confirming an esoteric interpretation nor denying it, still leaves the field open to other comments. It therefore seems perfectly justifiable to consider *El* as a sort of cinematic

equivalent to the surrealists' trompe l'oeil. Bourgeois psychology and morality play the role of perspective and photographic clarity in it, but this refined and orderly universe, marvelously legible, crackles neatly on the edge of the unbearable.

(June 10, 1954)

Reading over my review of *El* published last week, I wonder whether I emphasized enough the actual content of the film, which is far from forming a work of camouflage and distraction. On the contrary, for Buñuel, even without implying an unconscious esoteric meaning, *El* explicitly justifies itself as the objective study of a jealous man. Through an aesthetic paradox, the analysis of which is simple, surrealism in this film stems from an objectivity pushed so far that it penetrates its object through and through. It affirms this at first unmercifully, better to transcend its appearances, but does so by way of these appearances themselves. As in painting, psychological surrealism passes by way of the trompe l'oeil of realism, which here represents the rules and dramatic conventions of a bourgeois sociology. Thus in *El* we find the same sharp documentary objectivity that was the basis of *Land Without Bread*. Buñuel likes to say that his interest in Francesco [the hero] resembles the curiosity he would accord to the behavior of a rat. Because of his penchant for entomology he likes to look at his character as he would an insect. In *Land Without Bread*, do you recall the sequence with the anopheles mosquitoes, transmitters of malaria, that could be taken as a cinematic version of the *Illustrated Petit Larousse* encyclopedia?

The Criminal Life of Archibaldo de la Cruz

W e must neither under- nor overestimate the importance of this Mexican film by Luis Buñuel. There is no doubt that *Archibaldo de la Cruz* contains and develops some of the themes dearest to the author of *Un Chien Andalou* and does this perhaps most explicitly since that infamous film was made. *Archibald* is without a doubt a different kind of film; it is a sketch in which the author isn't as completely involved as he is in *El* and *Los Olvidados*. I think, however, that it would be a serious error to take *Archibaldo* as mere comedy and squash it by overly harsh criticism. This film is a very interesting work, and should have been released two or three years ago had it not been for the pusillanimity, which one can understand, of the distributors.

One can't help comparing *Archibaldo* to English black comedies, especially *Kind Hearts and Coronets* (1949), to point out the differences. A rich Mexican bachelor owns a music box, which is rumored to possess magical powers: it grants the wishes of its owner. But Archibaldo de la Cruz's wishes are actually obsessions. He dreams of gratuitous and bloody crimes, preferably crimes that involve pretty young women. He does not want his music box to do the job for him, but merely that it help him succeed. "Alas!" The spell works too effectively and, each time he embarks upon his perfect crime, Archibaldo is frustrated in extremis by the violent death of his intended victim. This keeps on happening. But one young woman escapes, probably because the plot allows for the substitution of a double, a wax mannequin that is her exact image. Annoyed or despondent, our man at least attempts to be punished as a criminal by denouncing himself to the police, who treat him with the amused respect due to a rich eccentric. This final failure gives Archibaldo the courage to rid himself of the famous music box and his obsessions. Set free, he is happy and runs into the young woman whom fate has spared (if she wasn't already, subconsciously, his lover)!

I mentioned *Kind Hearts and Coronets* only because of the plot line of the script and the macabre humor. Buñuel's film differs radically from the former through the disturbing and alarming repercussions that are diffused in what seems to be mere comedy. English black humor is a rhetoric, a pure intellectual convention, whereas Buñuel's humor is psychological, moral, and personal. It contains all the ambiguous and terrifying power of dreams, and its symbolism goes much deeper

through the echoes that reverberate in our consciousness. Another contrast that must be stressed is the erotic overtones, which are inseparable from the inspiration drawn from the dream. But this aspect of the film is mitigated to a great extent by the humor through which it is expressed.

(*Radio-Cinéma*—1957)

Cela s'Appelle l'Aurore

Luis Buñuel's reputation comes from the time when his films served as a banner for cinematic surrealism. There is scarcely a trace of this in *Cela s'Appelle l'Aurore*.

Buñuel's work and inspiration are partly misunderstood. Films like *L'Age d'Or* and *Un Chien Andalou* are indeed provocative, epic, and violent. They denounce social and moral lies, and are at times intolerably cruel. But it would be wrong to deduce from this that Buñuel seeks out scandal and violence for their own sake. The cruelty in *Los Olvidados* is merely the necessary counterbalance of an overwhelming tenderness, an unsatisfied yearning for kindness, justice, and purity in this world. For Buñuel, the dream and everything it reveals about inner reality is a pathway to the truth. To the casual viewer, some of Buñuel's work might seem filled with a gratuitous strangeness and bizarre incongruities.

But just as his "cruelty" is the projected shadow of his tenderness, Buñuel's oddities, if I may say so, are simply the manifestation of his simplicity. The universe of which he dreams is one of social justice, kindness, and true love—an almost naïve universe of moral simplicity. Naïve yet dizzying!

This is why *Cela s'Appelle l'Aurore* is truly a Buñuelian film, even though such a melodramatic story, with its strongly sympathetic or antipathetic characters, might seem to be naïvely paradoxical. A closer look shows us otherwise. This transparency is as sharp as crystal, and a shard might slit your wrists.

A young doctor, living on a desolate island in the Mediterranean, earns very little from his work yet remains to help those around him. His wife, slightly ill but mainly bored by her mediocre existence, goes to Nice to recuperate. Her parents would like to see their son-in-law set up practice on the Continent. While attending to a young girl who has been raped, the doctor meets a young Italian widow and violent passion soon envelops them.

Later, at great personal risk, the doctor is called upon to harbor a young man who has killed the reigning industrial boss of the town. The greediness and lack of compassion of the latter have led to the death of the young man's ailing wife. Wishing to spare the doctor an accusation of complicity, the unfortunate boy leaves his refuge and is killed.

In the end, the doctor divorces his wife, thereby renouncing the advantages of a career in the city and choosing truth, love, and the friendship of those who need him. *Cela s'Appelle l'Aurore* is, as I said, a strange film because of its simplicity, dazzling because of its

clarity, and a film which cleanses the soul and heart. It is admirably interpreted by Lucia Bose, Georges Marchal, and in particular Julien Bertheau and Esposito.

(1956)

Death in This Garden

U nlike Robert Bresson, Buñuel is not a director who can only work uncompromisingly and if the subject meets his complete approval. The author of *L'Age d'Or* and *Un Chien Andalou* has proven in many of his Mexican films, with their melodramatic and commercial scripts, that he can still remain true to himself while making concessions.

If Buñuel made films exactly as he wished, the screen would undoubtedly burst into flames at the first screening! Under the present conditions, his problem is how to express himself, in spite of everything, through the least "disgraceful" or most "respectable" scripts possible. He manages to do it through his insidious humility, patience, and good nature, which are the unexpected obverse of his genius.

This preamble is not aimed at diminishing the

scenario of *Death in This Garden,* which is one of his "respectable" subjects, but to state that this film does not exactly a priori contain a theme as perfectly "Buñuelian" as that of *Los Olvidados* or *El.* Nevertheless, within ten minutes an initiated viewer would surely attribute it to the director of *Subida al Cielo* and *Robinson Crusoe.*

The action takes place in some South American village where a strike has just broken out among workers from a neighboring mine. The police break the strike and, in the ensuing confusion, an adventurer, appearing out of nowhere (Georges Marchal), is arrested. He was robbed and denounced by the local prostitute (Simone Signoret). She inspires the true and rather ridiculous passion of a grocer (Charles Vanel), a widower burdened by a deaf-mute daughter. The widower dreams of marrying the prostitute and taking her back to France. The only thing of interest to this prostitute, who respects nothing, is the senile lover's money. Other notable protagonists are: the village priest, who despite being inclined toward established morality displays an innate decency under trying circumstances; and the owner of the little boat that links the village to towns along the river.

Following some episodes that I must skip over, all of these spirited and interesting characters, who harbor very different passions, find themselves aboard the boat, then alone in the jungle, the police on their trail. But, along with snakebites, the principal and paradoxical danger in this green hell is hunger. There is practically nothing edible to be found. From this point on, *Death in This Garden* would have to be an exotic adventure—were it not that, for Buñuel, the true adventure

lies in the human conscience. (In just the same way, he made *Robinson Crusoe* into a small epic of solitude followed by fraternity.) Here, death, love, and shared suffering bring true insight to each character and this changes them for the better—with the exception of one (Charles Vanel), who is driven mad by suffering and finally kills everyone but his invalid daughter and the adventurer, who, at the end, go forth to search for a new, unknown destiny.

If *Death in This Garden* is not Buñuel's masterpiece, it is nonetheless a beautiful and strange film that follows well-trodden paths only to end up putting us on the wrong track. His characters, seemingly straight out of a rather conventional adventure film, prove to be alarmingly human. The scenery smells of the sweat and suffering of the actors, who could not downplay the scorching heat of the sun or the dreadful climate. The color is wonderful and the acting always fascinating, even when it seems unwonted.

(1957)

Interview with Luis Buñuel by André Bazin and Jacques Doniol-Valcroze

We met Luis Buñuel, with whom we had been corresponding for a long time, at the last Cannes Film Festival. During the festival a few local papers persisted in speaking about his "cruel mask" and tirelessly repeated that his favorite word was the adjective "ferocious." Nothing could be further from the truth. Massive and slightly stooped over, Buñuel is reminiscent of the bull suddenly blinded by the arena lights. His slight deafness adds to the impression of restless solitude that he conveys. A thin barrier hides the man, gentle, calm, tender, reserved, and constitutionally incapable of the slightest compromise or the least hypoc-

risy. The following interview is an excellent portrait. Two things best define him, as much as this secret, shy, and modest Spaniard can be defined. One is the bright gaze of the entomologist. The second is the formula stated in this interview in connection with Robinson Crusoe and Friday: "They find each other again as proud men."

AB: Dear Luis Buñuel, French readers lost sight of you after *L'Age d'Or* and *Land Without Bread* and were surprised to rediscover you in a Mexican film in 1951. Would you briefly tell them something about your professional life since the thirties.

LB: In 1930, after *L'Age d'Or*, I left for Hollywood. I had been hired by Metro-Goldwyn-Mayer.

AB: Because of *L'Age d'Or*?

LB: Yes. M-G-M had seen the film in Paris and immediately signed up Lia Lys, the female lead in the film. M-G-M also wanted me to go to Hollywood under contract, but I refused. Deep down, I was not interested in making films under those terms. In Paris, I was free to make the films I wanted, with money given me by friends. Then, M-G-M hired me to be an "observer." I "observed" over a period of six months how films were made there, from script to editing.

In Hollywood I met Claude Autant-Lara again. . . . May I be quite frank?

AB: Of course. That's what we're here for.

LB: This is automatic writing! Well then, I met Autant-Lara, who had been hired to do French dubbings. The first day, the supervisor looked at my contract and said, "This is a strange contract, but . . . where would you like to begin: the studio, the script, or the editing?" I chose the studio. He then said to me, "Greta Garbo is

working on stage twenty-four. Do you want to go there as an observer for a month?" When I entered I saw Greta Garbo being made up. She looked at me out of the corner of her eye, wondering who this stranger was, and said something in an incomprehensible language (it was English—at the time my vocabulary consisted of "Good Morning"). She then signaled to a man who threw me out. From then on I only went to pick up my paycheck at noon every Saturday and no one paid any more attention to me. After three months of this, I went to see the supervisor again. He asked me to go see a screen test of Lili Damita—Do you remember her? "Are you Spanish?" he asked me. "Yes," said I, "but I'm here as a Frenchman because I was hired in Paris." "In any case," the supervisor said, "Mr. Thalberg asks that you go see a Spanish film featuring Lili Damita." I replied, "Tell Mr. Thalberg" (he was the boss of M-G-M)—Can I say the word I used?

D-V: of course.

LB: I told him I had better things to do than to listen to whores. Well, that was it. One month later I broke my contract with two months still to go. I returned to France, my trip and one month instead of two were paid for. That's all I did in Hollywood.

AB: You were in France at the beginning of 1931?

LB: Yes, in April 1931 to be exact, during the advent of the Spanish Republic. I stayed in Paris for two days, then borrowed some money, to go from Paris to Madrid by cab. A taxi took me from Paris to Irún and another from Irún to Madrid. I went back to Paris after I had read something by Maurice Legendre (who had become the director of the French Institute in Madrid) about the life of certain groups of backward people. It was a twelve-hundred-page doctoral thesis, a very complete and meticulous study of this way of life. This

book shook me up and gave me an idea for a film. A friend of mine, a Spanish worker named Acín, had said to me, "If I ever win the lottery, I'll pay for your film." Three months later he won the lottery. He was an anarchist and his anarchist buddies wanted him to divvy up the money. But he kept his promise and gave me twenty thousand pesetas. It was no fortune, but it did cover the expenses for Pierre Unick, Elie Lotar, and myself to go there.

AB: I thought that originally *Las Hurdes* had been commissioned by the Spanish government for social and educational purposes.

LB: Not at all. On the contrary, it was banned by the Spanish Republic as a dishonor to Spain and as denigrating the Spanish. The government officials were furious and the embassies were instructed not to let the film be shown abroad because it was an insult to Spain. It wasn't shown in France until 1937, in the middle of the Spanish civil war.

AB: Who did the narration?

LB: Pierre Unick. We wrote it together.

AB: Whose idea was the music?

LB: Mine. I had particular ideas about music in films.

D-V: Wasn't Grémillon involved in it somehow?

LB: No. I only met Grémillon four years later, in Spain, where I invited him to be a director. I was a producer at the time. Because he liked Spain, he came for a very small fee.

AB: Certain scenes were cut by the censors, particularly in the cockfight scene.

LB: Yes. When the film came out in France in, 1937 I believe, the Savoyard newspapers protested loudly. They claimed that tourism in Grenoble was threatened because the film's opening remarks stated that there were some places in Europe—in Czechoslovakia, in

French Savoy, and in Spain—where groups of people lived untouched by civilization. Savoie protested vigorously. It was Madame Picabia who told me that there is a village in Savoy, like Las Hurdes, buried in snow six months of the year, where bread is almost unknown and nearly everyone is inbred.

AB: By your lights, what is the relationship of a film like *Land Without Bread* with your previous work? How do you see the relationship between surrealism and the documentary?

LB: I see a distinct connection. I made *Land Without Bread* because I had a surrealist vision and because I was interested in the problems of man. I viewed reality in a different way than I would have before surrealism. I was sure of this and so was Pierre Unick.

AB: You said that in 1934 you were a producer in Spain. After *Land Without Bread,* did you stay in Spain to work in film?

LB: After *Land Without Bread* I worked in Paris. I didn't want to make any more films. Thanks to my family I had the funds to live on, but I was a little ashamed of being idle. I did some dubbing work at Paramount in Paris for two years, then I was sent to Spain by Warner Brothers to manage their co-productions. I ended up doing dubbing again. Then I found a friend, Urgoiti, and as his producer I began to make films. I did four uninteresting ones—I've forgotten their titles. Then the Spanish civil war broke out. I thought the world had come to an end and that it was time to think about doing something more constructive than making films. I entered the service of the Republican government in Paris, and in 1938 it sent me to Hollywood on a "diplomatic mission" as technical adviser for two films on the Spanish Republic. When the war ended I was in Hollywood. I found myself in America, completely on my

own and out of work. Thanks to Miss Iris Barry I got a job at the Museum of Modern Art. I thought we would do great things there, but I ended up doing bureaucratic work. I had fifteen or twenty employees and was in charge of Latin American translations. I subsequently was forced to hand in my resignation when it was discovered that I was the author of *L'Age d'Or.* Miss Barry accepted my resignation with tears in her eyes. It was the day of Toulon * and the atmosphere was tense. Reporters came to see me but I refused all interviews. I found that at that point in time it didn't matter if Mr. Buñuel was inside or outside the museum. I was very sad. I had no savings, and the following days were rather grim. Then the American Corps of Engineers hired me as an announcer for U.S. Army films. I used "my beautiful voice" in fifteen or twenty films about soldering, explosives, airplane parts—in short, for technical films that were being made at the time.

AB: Did you speak English that well?

LB: No, this was still for Spanish versions.

D-V: Did your departure from the museum have a direct relationship to the publication of Dali's book? Was it through him that it was learned you had made *L'Age d'Or?*

LB: Yes.

D-V: So you worked for the Army Engineers.

LB: Yes, in New York. I was subsequently hired by Warner Brothers and sent to Hollywood. They expected to make quite a few Spanish dubbings. I must tell you that I'm lazy, but when I work, I do work hard. They hired me as a "producer" and paid me well. But these Spanish productions never got under way, and once again I was employed as a dubbing specialist.

D-V: What year was this?

* On November 8, 1942, the French fleet scuttled itself so that it would not fall to the British.

LB: I spent two years in Hollywood, from 1944 to 1946, and as I was relatively well paid I was able to save enough to realize my life's ambition for a year—to do nothing. I had no money left when Denise Tual asked me to come to Mexico in 1947. She wanted me to make a film in France. I was delighted. I thought the heavens had opened up. She wanted me to do *The House of Bernarda Alba*, but it couldn't be done because García Lorca's family had already sold the rights. However, in Mexico I met Oscar Dancigers, who proposed a film to me. I made it and I've stayed in Mexico since then.

AB: Which film was that?

LB: A musical. There were tangos in it and God knows what else . . . but a lot in any case. It was called *Grand Casino*. The story took place in Tampico during the oil boom. The script was not too bad. The greatest singers of Mexico and Argentina were in it—Jorge Negrete and Libertad Lamarque—I made them sing all the time. It became a contest, a championship. The film wasn't very successful and I was out of work for the next two years.

D-V: Was Oscar Dancigers always your producer down there?

LB: Yes. I owe him a great deal. It is thanks to him that I was able to stay in Mexico and make films.

AB: Is it true that in Mexico you worked only under very "commercial" conditions? Are productions done in such a way that one must make melodramas or very simplistic films?

LB: Yes. And I complied.

AB: But how about *Los Olvidados*?

LB: It was different with *Los Olvidados*. Despite the failure of *Grand Casino* and the two years of inactivity that followed, Dancigers asked me to come up with a subject for a film for children. I timidly showed him the script of *Los Olvidados* that I had written with my friend

Luis Alcoriza. He liked it and told me to work on it. Meanwhile, I had the opportunity to make a commercial comedy, and Dancigers proposed that I make that one first in exchange for which he would assure me a certain freedom for *Los Olvidados*. I made *The Great Madcap* in sixteen days. The film had a tremendous success. I was then able to begin work on *Los Olvidados*. Dancigers did ask me to take many things out of the film, but nevertheless left me a relative freedom.

AB: What kind of things?

LB: Everything I had to cut had a purely symbolic interest. In the more realistic scenes I wanted to inject wild and completely disparate elements. For example, when Jaíbo is about to fight and kill the other boy, the camera reveals the skeleton of a large eleven-story building under construction. I would have liked to put a hundred-piece orchestra there, to be seen fleetingly in passing. I wanted to put in many elements along these lines, but was absolutely forbidden to do so.

AB: What you are saying is all the more important that *Los Olvidados* passed for a film with a social and pedagogical bent while at the same time following in the tradition of *The Road to Life* (Nikolai Ekk, 1931), *Boys' Town* (Norman Taurog, 1938), and *Prison Without Bars* it seems to contradict the notion of social realism that was imputed to the film. It would be important if you could tell us to what extent this realism is necessary. Or is it there on the contrary to put us on the wrong track of the true poetic message of the film?

LB: For me, *Los Olvidados* is actually a film of social struggle. I had to make a social kind of film. I know I am going in that direction. Except for that, I absolutely did not want to make a film with a message. I observed things that moved me and wanted to transpose them to the screen, but always with that relentless love for the

instinctive and irrational. I've always been attracted by the unknown or strange side of things. I've never understood my own fascination.

D-V: You had Figueroa as a cameraman but you made him work differently from his usual style. Did you prevent him from taking his usual beautiful shots?

LB: Naturally, because the film did not lend itself to that.

D-V: He must have been very upset.

LB: Very much so. After eleven days of shooting Figueroa asked Dancigers why he had been chosen to shoot a film that any newsreel cameraman could have done just as well. He was told, "Because you're a very fast cameraman and very commercial." It's true. Figueroa is extraordinarily fast and excellent. That reassured him. At first he was very surprised to be working with me. We rarely agreed on anything. But I think he changed in the course of the filming and we became great friends.

AB: What about *El*? What does *El* symbolize in your Mexican work? Did you knowingly introduce what some of us wanted to see in it? Were you aware of weaving a kind of *L'Age d'Or* into a very corny script?

LB: I did not—or at least not consciously so—wish to imitate or follow *L'Age d'Or*. The hero in *El* is a guy who interests me, like a beetle . . . I've always been fascinated by insects . . . an old entomological streak in me. Examining reality interests me very much. With *El*, I worked as I always did in Mexico: a film was proposed to me and instead of accepting it outright I tried to work out a counterproposal. Though my proposal was still commercial, it nevertheless seemed a better way of expressing some of the things I wanted to say. This was the case with *El*. *L'Age d'Or* did not come into play. Consciously I wanted to make a film on love and jeal-

ousy. But I recognize that one is always attracted by the same inspirations, the same dreams, and it is highly possible that I ended up doing things which inevitably resembled *L'Age d'Or*.

D-V: The rather terrifying scene where the husband tries to sew up his wife—did the producers understand it?

LB: I don't know. When choosing certain elements I did not really think of imitating Sade, but it's possible that I did so unconsciously. I'm more naturally inclined to view and conceive a situation from a Sadian or sadistic point of view rather than, say, a neorealistic or a mystical one. I said to myself: What should the character use—a gun? a knife? a chair? I ended up choosing more disturbing objects, that's all.

D-V: At the end of the film when the hero has become a monk and zigzags down the road, what does that mean to you?

LB: Nothing. It made me laugh a lot to see him walk that way. It doesn't mean anything. I just enjoy it.

AB: If *Los Olvidados* was a relatively free film, *El* is then a commissioned film in which you introduced—consciously or not—many of your own personal ideas. But do you also consider *Susana*, for example, or *Subida al Cielo* as small commercial films in which you occasionally succeeded in introducing something personal? We attach more importance to them than you seem to and we also see a very palpable richness about them. Are they exclusively commercial works for you?

LB: No. I weigh them by the pleasure I derive from making them. *Susana* would have been more interesting if I had been able to have a different ending. I made the film in twenty days . . . but the amount of time doesn't matter—five months or two days—that's not what is important. What matters is the content and the expres-

sion. I liked *Subida al Cielo* a great deal. I love the moments when nothing happens. The man who says: "Give me a match." This kind of thing interests me a lot: "Do you want to eat?" or "What time is it?" I made *Subida al Cielo* a little in this vein.

D-V: What is the chronological order of your films after *Los Olvidados*?

LB: After *Los Olvidados* I made *Susana*, then another film that will never come here and whose title I don't even remember. You know, the films I did in Mexico are sent over here without my being advised. It's the government that decides this, or perhaps it's an agreement between producers. I myself never wanted to send my films to festivals or anywhere else.

After that, I made *Subida al Cielo* and then *The Brute*, also made very quickly—in eighteen days. *The Brute* could have been very good. The script by Alcoriza and myself was fairly interesting but they made me change everything from top to bottom. Now it's a mediocre film.

D-V: Then you shot *Robinson Crusoe*?

LB: I made four films after *The Brute*. *Wuthering Heights, Robinson Crusoe,* and *La Ilusión Viaja en Tranvía* . . . the story of a streetcar stolen by two workers. They start off from a café and flash through the city on the stolen streetcar . . . there's one fairly interesting reel. The fourth film is called *El Rio y la Muerte*. It's about the Mexican way of death, that so-called "easy death." You know, when a man dies people come to smoke and drink little glasses of liquor. Life is a trifling thing and death doesn't matter. In the film there are seven deaths, four funerals, and I don't recall how many wakes.

AB: Was *Robinson Crusoe* an important film for you?

LB: Like the others, *Robinson* was proposed to me. I

didn't like the novel, but I did like the character and I accepted the project because there was something pure about him. First of all, he was a man in the presence of Nature. There is no romance, no easy love scene, no serialized romance, nor complicated plot. He is simply a guy who arrives on an island, finds himself faced with Nature and must feed himself. Since I liked the story, I agreed to make the film, and tried to do things that could have been interesting. Some of it remained in it but many of the so-called surrealistic and supposedly incomprehensible passages were cut. The film begins with Robinson's landing; the first shot is of the waves throwing a man upon the island. For seven reels he remains in the deepest solitude with only his dog for company. Then he meets Friday, who is a cannibal and Robinson cannot talk to him. They spend three reels trying to understand each other. Finally, pirates take Robinson away. I made the film as best I could, trying to show above all man's solitude and anguish without human companionship. I also wanted to treat the subject of love . . . I mean the lack of love or friendship, man without the company of man or woman. All the same I think that, in spite of the cuts, the relationship between Robinson and Friday remains fairly clear: the connections between the "superior" Anglo-Saxon race with the "inferior" black race. At first Robinson is suspicious and imbued with his superiority. But in the end brotherly love triumphs. They find each other again as proud men. I hope this meaning will be evident.

AB: And *Wuthering Heights*?

LB: That's a strange story. I had wanted to make this film at the time I made *L'Age d'Or*. We surrealists thought it was a wonderful book. I think Georges Sadoul translated it. They loved the aspect of *l'amour fou*—love above all else. Being part of that group I

shared the same ideas about love and thought the book was terrific. However, I couldn't find a producer and the film remained among my papers. Hollywood made a *Wuthering Heights* eight or nine years later and I dropped the project. Dancigers, who had Mistral, a well-known Spanish actor, and another Spanish star, Irasema Diliam, under contract, asked me to make a film whose script I didn't like. Dancigers then reminded me of my earlier adaptation of *Wuthering Heights* and asked to see it. He agreed to do it. I had lost interest in this film, and didn't attempt to be innovative. It remains the film I envisioned in 1930, a twenty-four-year-old film. I do think, however, that it's faithful to Emily Brontë's spirit. It's a very austere film, without concessions, and one which respects the meaning of love in the novel.

AB: Given the conditions of producing in Mexico, you were forced to make your films very quickly, weren't you?

LB: Very quickly. Except for *Robinson Crusoe.* I made all the other films in twenty-five days of shooting. That's not unusual in Mexico. Some films are shot in even less time. It is very rare in Mexico that the shooting of a film lasts five weeks. Only four of us are able to wangle twenty-four to twenty-five days to do so.

D-V: Even Fernández?

LB: No, he's an exception. He's allowed to do all sorts of things.

AB: I understand that you've kept your ties with surrealism, if not in an official and orthodox way, at least in inspiration. Is it true that rather than denying your surrealist background it is still very much alive and that its influence continues to be very strong?

LB: I don't deny it at all. It is surrealism that showed me that in life there is a moral sense that man cannot

permit himself to ignore. Through it I discovered for the first time that man is not free. I believed in man's total freedom; but in surrealism I saw a discipline to follow. That was an enormous lesson in my life as well as a great poetic leap. I haven't actually belonged to the group for a long time.

AB: You've often told us of your laziness and of often having been on the brink of stopping to make films altogether. You've also said that you seldom go to the movies. The Cannes Festival must have been an exceptional opportunity for you to see films. How many times a year do you go to the movies?

LB: Very rarely. I don't want to exaggerate, but let's say four times a year. It could be six times or two but it averages out to four times.

AB: But there must be something fairly deep that binds you to the cinema—in spite of your claiming to be lazy, the difficulty you have in making films, and the little pleasure you have in seeing them. Then what draws you to film rather than another profession or other forms of expression, such as writing or painting?

LB: If I don't like going to movies, I do like film as a means of expression. There's no better medium for showing us a reality that we would otherwise be unable to touch with our fingers. What I mean is that through books, newspapers, and our experiences we come to know an external and objective reality. Film, through its technique opens up a little window onto the extension of this reality. My wish, as a film viewer, is that a film make me discover something new. But that rarely happens. The rest doesn't interest me. I'm already too old. I'm pleased to have been able to see so many films at this festival. There were some great films, but it all left me indifferent. Film very rarely brings me what I am looking for and that's why I almost never bother to go. But I have friends who recommend films to me and

who even force me to see them. That's how I came to see *The Forbidden Games*, which did open that little window for me; it is an admirable film. I also saw *Portrait of Jennie* (William Dieterle, 1948), which I also liked very much and which opened a large window for me. From a professional standpoint, I'm unforgiving. I should see more films, go to the movies every day . . . I'm the first to admit it. In Mexico, when I'm asked to cast a film, I never know what to say since I don't know enough actors. It's really bad, I know, but I prefer to stay quietly at home and drink whiskey with friends than going to the movies.

AB: You told me that one day, however, thanks to Denise Tual you were able to see *Les Anges du Péché* (1943) by Robert Bresson and that the scene of a nun having her feet kissed remained engraved in your memory.

LB: Ah yes, a very beautiful scene and a very beautiful film.

AB: I found it a little surprising because that image doesn't seem to be the most characteristic one in the film.

LB: I see what you mean. It's not that I am at all sadistic or masochistic—only in theory. I only accept these elements as being those of struggle and violence. Throughout Bresson's film I had a premonition of something about to happen that attracted me very much. The final scene was in fact the troubling manifestation of this. That is why I only remember someone kissing a dead nun's feet. But I myself don't like kissing dead nuns' feet, nor that of green cows, nor any feet at all for that matter. But there it was like the flowering of certain occult feelings present throughout the film.

AB: Could you tell us what you think of film music and specifically about the music in *Land Without Bread* ?

LB: I was once in New York for a convention of the

Association of Documentary Film Producers. The most famous young composers for American films were there. *Land Without Bread* was shown and one of them enthusiastically came up to ask me how I got the wonderful idea of using music by Brahms. I hadn't made any great discovery but had simply found that Brahms's music corresponded to the general mood of the film. I used the Fourth Symphony. I remember there were four Brunswick records. Everyone was amazed by such a simple, almost absurd answer. People are always looking for special effects and complications. Personally, I don't like music in films. I find it a cowardly element, a kind of trickery—except in certain cases, of course. I was very surprised to see some wonderful films without music at this festival. I could name three or four of them where there were sections of twenty minutes or longer without any music. *The Great Adventure* (Arne Sucksdorff, 1953), for example. Now that I'm deaf, maybe I didn't hear any and there was really a twenty-four-piece orchestra playing the whole time, but it makes no difference to me. It proves to me in any case that silence would have been better.

D-V: There's practically no music in *The Great Adventure*.

LB: In the Japanese film *Gate of Hell* (Teinosuke Kinugasa, 1953) the music is also very special. I therefore see the possibility of doing away with most music in the movies. Ah! Silence! *That's* what's really awesome. I've discovered nothing about music; but instinctively I consider it a parasitic element which serves above all to enhance scenes that otherwise would have no other cinematic value. In making *Wuthering Heights*, I flashed back into my state of mind in 1930. Since at that time I was madly Wagnerian, I used fifty minutes of Wagner.

AB: And now, do you have an idea or hope for a project that would emanate from you yourself, a film that's not imposed on you?

LB: I have an idea for a two-reeler that I'll do with a crew of friends, some technicians in Mexico. Something fairly good, I think, but not at all commercial and that could only be shown in cinematheques and art theaters. But I can't talk about the subject yet. . . .

5 Alfred Hitchcock

Born in London in 1899,
Hitchcock died in 1980. He directed:

BRITISH SILENT FILMS: *Number Thirteen* (unfinished, 1922); *The Pleasure Garden, The Mountain Eagle* (1925); *The Lodger* (1926); *Downhill, Easy Virtue, The Ring* (1927); *The Farmer's Wife, Champagne* (1928); *Harmony Heaven, The Manxman* (1929).

BRITISH SOUND FILMS: *Blackmail* (1929); *Elstree Calling, Juno and the Paycock, Murder, Mary* (German version *Murder*) (1930); *The Skin Game, Rich and Strange* (1931); *Number Seventeen* (1932); *Waltzes from Vienna* (1933); *The Man Who Knew Too Much* (1934); *The Thirty-Nine Steps* (1935); *Secret Agent* (1936); *Sabotage, Young and Innocent* (1937); *The Lady Vanishes* (1938); *Jamaica Inn* (1939); *Bon Voyage, Adventure in Malagua* (1944).

AMERICAN FILMS: *Rebecca, Foreign Correspondent* (1940); *Mr. and Mrs. Smith, Suspicion* (1941); *Saboteur* (1942); *Shadow of a Doubt, Lifeboat* (1943); *Spellbound* (1945); *Notorious* (1946); *The Paradine Case* (1947); *Rope* (1948); *Under Capricorn* (1949); *Stage Fright* (1950); *Strangers on a Train* (1951); *I Confess* (1953); *Dial M for Murder; Rear Window* (1954); *To Catch a Thief, The Trouble with Harry* (1955); *The Man Who Knew Too Much* (1956); *The Wrong Man* (1957); *Vertigo* (1958); *North by Northwest* (1959); *Psycho* (1960); *The Birds* (1963); *Marnie* (1964); *Torn Curtain* (1966); *Topaz* (1969); *Frenzy* (1972); and *Family Plot* (1976).

Shadow of a Doubt

"**A** detective thriller," says the poster. Alas, yes. A detective thriller film like so many others, avoiding none of the conventions that Americans love to recognize in the films they see. But this film could have been something better and at times it attains a kind of hallucinating and harsh grandeur. Because of these uneven high moments in the film, *Shadow of a Doubt* definitely merits attention.

The action takes place in one of those average, ideal provincial families. Hollywood's social apologetics have been particularly attached to them since the war, in films such as *Our Town* (1940), *The Human Comedy* (1943), and others. Papa works at a bank, Mama is gay and spirited, like Fay Bainter herself. The older daughter is pretty and pure; the younger wears pigtails and glasses. . . .

ALFRED HITCHCOCK 103

Uncle Charlie shows up in this paradise of familial love.

Uncle Charlie is Mama's brother, and his relative youth has made him the spoiled child of the family. Uncle Charlie is handsome, strong, and intelligent, and in this film he is rich. He arrives like Santa Claus; his arms are laden with gifts. But the most beautiful gift of all is the emerald ring he slips on his niece's finger.

There are, however, odd initials engraved on the ring. The next day, two reporters appear and they insist upon photographing Uncle Charlie. Uncle Charlie tears up an article in the morning paper which has made him turn pale. He also makes strange comments about the world in general, and about rich old women in particular. The shadow of a doubt is beginning to gnaw at the young woman. She wants to understand, but what she discovers is terrifying. Uncle Charlie, this beautiful archangel, has murdered three very rich widows. The reporters were really detectives. His arrest depended upon the photograph they wanted to take of him.

But the arrest does not take place. The police, thrown off the track, believe they have discovered the real murderer of the "merry widows." Free of the detectives, the young man hopes to remain in the peaceful bosom of the family. The presence of his niece, however, poses a threat. He attempts to kill her three times. Will the film end on an excruciating close-up of fingers, one by one releasing the emergency brake of a train?

The pervading justice of melodrama reaffirms its rights just in time: Uncle Charlie falls on the railroad track, thus allowing Teresa Wright to marry the young detective she met during the investigation.

The writer and director obviously did not have the courage to follow their intent to the end. There are elements here for a profound study of morals and character. Had his psychology been more strongly asserted, the character of Uncle Charlie could have transformed this quaint picture of provincial life into a more penetrating satire.

The direction, however, reveals ever so fleetingly what the film could have been had Hitchcock deliberately chosen between the conventions of the genre and his true subject. I am haunted by that hand wringing a piece of paper as if it were a woman's neck; of a shot on the staircase where the murderer feels the young girl's gaze weighing upon him; of a close-up where a nearly imperceptible change in Joseph Cotten's glance reveals the ruthless despair of a condemned man.*

Once again we see that if the cinema so rarely attains the quality of great American literature it is not because the possibilities of expression in films are inferior to those of literature, but only because the cinema recoils before the normal demands of the art.

(*L'Ecran français*—October 3, 1945)

* In *Le Parisien Libéré*, André Bazin analyzed the same film in a considerably more favorable light: "This film wavers between a standard detective adventure and a study of morals and character. If Hitchcock had deliberately opted for the latter, this certainly would have been a classic work. The few passages where the director dared confront the subject are among the most beautiful and powerful in all psychological cinema. Joseph Cotten gives life to an Uncle Charlie who is as handsome and as powerful as a condemned archangel."

Suspicion*

A dialogue in a tunnel. The man apologizes for having bumped into the woman while taking a seat in a train compartment he thought was empty. A magazine photograph tells us that he is the young and seductive Johnny Esgart. The conductor comes by. The man is in first class with a third-class ticket. To make up the difference he needs only a few pennies, which he borrows—with a charming shamelessness—from the young woman. Later, when Johnny and Lina are married, she slowly discovers some terrible and ambiguous facts

* Note that these essays on Hitchcock do not follow the chronological order in which the films were made, but follow their unchronological appearance in Parisian theaters. We want to show the evolution of Bazin's thoughts on Hitchcock rather than the director's progression.

about him. Did her husband marry her in the hope of living off his in-laws? Or is he merely an irresponsible child, incapable of saving money and finding it normal to live off others? Does he love her? Is he using her? The more and more dubious schemes into which he plunges to obtain the thousands of pounds he needs—are these cynical maneuvers or the lies of an indolent child? Is he capable of murdering his best friend, having made him a partner in a shady business deal to obtain a large advance? Would he go so far as to calculate the advantages of his wife's death (the five hundred pounds in insurance money)? But why would he inquire about a poison that leaves no trace? Why doesn't the car door close properly on the side where his wife sits as he drives recklessly along the edge of a cliff?

But no. Everything can be explained. The gesture made when the car door opened was to hold her back. The poison was for a noble suicide, and his friend Bob died a natural death. But we *were* afraid.

Up until the final shot Hitchcock manages to make us walk a tightrope over an abyss, pushing us first lightly to the left, then to the right, catching us each time at the exact moment we think we are falling. The ambiguity of the main character and the ambivalence of the situations are managed from beginning to end with diabolical competence. The progression of this hallucinating dramatic pitch is knowingly treated with caution—up until the paroxysm of the final pseudoaccident. All too happy to get out of it so easily, the viewer undoubtedly imagines that the story will begin again without him, that this car bringing back two lovers also brings them back to their worries, their ruin, their dishonor, and new suspicions.

It is good to know that in the novel by Francis Iles, on which the film is based, the hero was really a criminal and the wife, at the height of her terror and love, preferred to let herself be killed. Hitchcock's direction and Samson Raphaelson's dialogue are too intelligent for us to question the full aesthetic consciousness of the authors in this important optimistic modification in the script. It measures the boundaries of Hitchcock's talent for expression—a fairly vain talent in its cruel refinement. Will this technique of Suspicion one day give us something other than a shadow of the authentic tragedy of Doubt?

(*L'Ecran français*—October 29, 1946)

Notorious

A n espionage film is an espionage film. The rules of
the genre are no less international than the thing
itself. The scriptwriter Ben Hecht did not exert himself
in his reexamination and enlargement of this transla-
tion into the "American" of Marthe Richard in the
service of the atomic bomb. The lovely spy (Ingrid
Bergman), out of love for the handsome secret agent
(Cary Grant), dutifully agrees to marry the traitor
(Claude Rains). The traitor is withholding valuable
secrets about a certain uranium deposit. Bergman
achieves her goal, but is suspected and slowly poisoned
by her husband and mother-in-law. Cary Grant arrives

in the nick of time to deduce what is happening and save the heroine from the indirect consequences of radioactivity. We see that the classic situation of the virtuous spy sacrificing her virtue for secrets of state is appreciably improved here.

With *Shadow of a Doubt,* Alfred Hitchcock had given us a near masterpiece. The mysterious conventions of distribution have up until now prevented us from seeing *Lifeboat,* where all the action takes place in a lifeboat—and which, I hear, is an excellent film. But it seems quite definite that these are the only good films that the author of *The Thirty-Nine Steps* made in America. Alfred Hitchcock's language is certainly the most splendid in the world. Moreover, we now know that he is peerless when it comes to spiral traveling shots and expressing the most secretive movements of anxiety and doubt. He has extended the limits of the camera's sensitivity, in the sense that we say that a scale is sensitive. Unfortunately, there is something ridiculous about placing the vulgar iron filing of these ready-made psychologists on the scalepan that would register a speck of gold dust. It is all well and good to make use of the subjective camera, but there must be a subject!

In spite of its impossible scenario, *Notorious* is nonetheless perceptibly superior to *Rebecca* (not to mention *Spellbound,* shown at the Venice Film Festival, which is by far the worst). At times the subtlety of the technique manages to instil a trace of life into the characters. I am thinking in particular of that first scene, where the ambience of a party, at that ghastly hour when the guests waver between drunkenness and hangover, is rendered by sticky, glaucous, and almost nauseating directing. Flowing along with the odor of tobacco and whiskey, a

feeling of boredom and despair is a good introduction to the characters.

Ingrid Bergman is Ingrid Bergman. Let the reader decide.

(*L'Ecran français*—March 16, 1948)

Pan Shot of Hitchcock

I t's time to say what follows, otherwise the critical and public success of *The Paradine Case* and the admiration for the technical tour de force of *Rope* run the risk of firmly establishing what seems to me to be a kind of critical swindle: since 1941, Hitchcock has contributed nothing essential to cinematic directing. Mentioning his name along with that of Orson Welles or William Wyler (which I have also been guilty of doing) as one of the principal champions of Hollywood's avant-garde, stems from an illusion, a misunderstanding, or a breach of trust.

This said, a sense of hierarchy is necessary. Hitchcock remains one of the most clever directors in the world, one of the three or four to be a master of his craft. J. Queval speaks of his British films that demonstrate not just an exceptional mastery of technique but an

intelligence, humanity, and humor which make him a harbinger of the renaissance of modern British cinema. There is no longer any doubt that his first American film, *Shadow of a Doubt,* contained—in spite of dazzling inventiveness, a powerful originality of tone and scenario—strange echoes of Faulkner and Dostoevski. I would even grant that *Notorious,* a film as misunderstood as *Gilda* (Charles Vidor, 1946), contains an artful acidity under the overprovocative guise of the worst conventions. Yet another point: if today I decide to attack a director who is considered by certain of my colleagues as one of the pillars of the present cinematic "avant-garde," it is not to jeopardize this notion which is dear to us all. Hurray for Hitchcock—in spite of his detractors! But just between us, we've been had. Let's have the courage to say so before it becomes an alibi for the daring and the avant-garde. Let's hope that even after ten years of heresy Hitchcock will return to us one day. The worst part is that he might do it.

Here are my arguments. Putting aside *Spellbound* and *Saboteur,* let us consider his three best films since *Shadow of a Doubt,* which are *Lifeboat, The Paradine Case,* and *Rope.* The first is the best. But if the scenario is fascinating and original (the entire film takes place in a lifeboat after the torpedoing of a freighter), its audacity is to a great extent formal. This paradoxical unity of place definitely confers an added tension to the film, and one must also be particularly skilled to extricate oneself from the directing problems it causes.

Hitchcock demonstrated his skill here, but without using any language other than a standard one. On these few square feet, "shot" and "reverse shot" succeed each other shamelessly. *The Paradine Case* should have

removed any remaining doubts, from those who still had them, with respect to the originality of Hitchcock's language. I defy them to find two shots of a nontraditional concept. I say two because there is an indisputably sensational one: the pan on Louis Jourdan around the witness stand with Alida Valli as its center. *That* is cutting! But a shot in a film which is presented as the be-all and end-all of direction is no great thing. The whole secret of *The Paradine Case* is Hitchcock's science of manipulating a track-in on a character. The famous impression of anxiety of which he is the grand master is entirely due to his speed and his frames of arrivals and departures.

We finally arrive at *Rope*, which is said to be the apex of the revolution in film directing, as the director filmed it in only ten shots: a single take for each ten-minute reel.* The result? Certainly an interesting one and less boring than *The Lady in the Lake* (Robert Montgomery, 1946) because the material is good and its subject has a particular affinity to the continuity of the takes. The young murderers who give a surprise party for the friends and relatives of their victim (whose body lies in the chest on which sandwiches and drinks are placed) are indeed captured in a rigorous and dense moment—in a state of anxiety which knows no end. But Hitchcock's cutting in fact refers to classical cutting. Each time we are struck by his effectiveness, it is because he has managed, at the cost of a thousand resolved hardships, to create the impression of shot and reverse shot or a close-up where it would have been easy

* And, in fact, for the viewer, it seems like a single take, since the cuts needed for changing reels are imperceptible.

to use a single take like everyone else. This directing through continuous traveling shots—which is simply an endless succession of reframings—is completely different from Wyler's "stationary shot" or from Welles, who managed to integrate into a single frame many moments of a virtual editing.

On the path which he has now undertaken, Hitchcock restricts himself to returning to a traditional cutting of strange resonances and bizarre effects. He is the Edmond Rostand to John Ford and Howard Hawks and the Heredia * of *Suspense.*

(*L'Ecran français*—January 23, 1950)

* José-Maria de Heredia (1842–1905) was a Parnassian poet who strove for perfection in form.

The Thirty-Nine Steps

Commercial exploitation seems to be following the example of the art theaters, which feature old hits. Why does film not follow in the footsteps of the theater, which never has qualms about digging into its repertory?

Thus we can applaud the "revival" of Alfred Hitchcock's *The Thirty-Nine Steps*. This film, made in 1935 by the director of *The Paradine Case* and *Rope,* happens to be the film that earned him international fame. It remains indubitably his masterpiece and a model for detective comedies.

As in a Graham Greene novel, an innocent finds himself helplessly hurled into a terrible affair of espionage, whose ins and outs he is unaware of, but which he nonetheless must resolve by feeling his way and risking his life. A sort of ironic fatality seems to allow him to

escape from one trap only to rush headlong into a more terrible one. This story is told with a humor that can only be partly explained by the British origins of the film. While watching certain scenes, with their unobtrusive yet firm audacity, we can nostalgically measure how conventional films have become in the last fifteen years. A marvelous, flawless rhythm gives life to the film from beginning to end. The technique and acting seem somewhat dated, but as Mr. Hitchcock himself no longer knows how to make films like this, we should really overlook these anachronisms.

(June 17, 1951)

Must We Believe in Hitchcock?

No one would argue that Alfred Hitchcock is the most clever man in all of world cinema. Each of his films is a journey to the outer limits of film technique from which we return dazzled, as if by fireworks. What there is beyond this remains to be seen.

When Hitchcock left the British studios for Hollywood in 1939, he had already given the British cinema one of the rare first-rate films that had been produced before the war, *The Thirty-Nine Steps*. Although it was made in 1935, this film has not aged—except perhaps in some minor technical details. But the technique is not so important. It is basically a scenario film (and what a scenario!) and one which is concerned with directing the actors. If perhaps not acrobatic the direction is fast and brilliant. Upon his arrival in America, Hitchcock

was probably already rated as a specialist in detective films with a special atmosphere and psychology but not particularly as a virtuoso of the camera. Thus, as it often happened in Hollywood, Hitchcock reestablished himself in his specialization with his choice of subject. On the other hand, he quickly revealed himself as more and more inclined toward technical effects and toward the prowess of staging and directing—not in the grandiose and spectacular sense, but in the more subtle aspect of cinematic expression. With *Shadow of a Doubt, Spellbound, Notorious,* and *Lifeboat,* Hitchcock became the indisputable Cecil B. De Mille of cutting. Two unique exploits in film history, bordering on the impossible if not the absurd, mark this experiment. In *Lifeboat,* the unity of place is reduced to the dimensions of a lifeboat; and in *Rope,* the unity of time is respected to the extent that the film is shot in one single take without interruption (really in ten shots because the reels are only three hundred meters long; but this contingency is purely accidental and the coupling at the end of each reel is unnoticeable).

Shadow of a Doubt dates from 1942 and *Notorious* from 1946. These films came out immediately after the war, at about the same time as *Citizen Kane* (Orson Welles, 1941) and *The Little Foxes* (William Wyler, 1941). They caused a considerable commotion at the time and the "young critics" consecrated Alfred Hitchcock among their American gods. He appeared to them as one of the principal hopes of the major evolution that was happening in Hollywood between 1940 and 1944, and which we in France experience now. It was the period when Alexandre Astruc launched the slogan *"caméra-stylo."* As a pen, Hitchcock's camera was a

tailor-made Parker.* It could write everything and everywhere—underwater, its feet on the wall, hands behind its back . . . the image slid onto the film without the thousand little antiquated hitches of the editing typewriter. With Hitchcock, the camera would know the joys of the sequence of tenses and the imperfect subjunctive.

I am experiencing second thoughts. My last illusions vanished upon seeing *Rope,* where it is clear that technical feats added almost nothing. In reality there was no big difference between what was introduced by Welles, Wyler, indeed even Dmytryk or Mankiewicz, and the route taken by Hitchcock. Not that his technical displays should be considered frivolous. They have substantiated and continue to substantiate a cinematic fact that only recently has been fully perceived: the knowledge that there is not just the scenario + the directing as there is in a script for a play, but that there is only writing and style as in a novel. The interest in such research was not, however, to enrich cinematic technique, because in that case, Hitchcock did not invent anything vital (nor did Welles, in fact). Hitchcock simply found another use for this technique.

It was therefore foreseeable that the imagination and daring of the years from 1940–45 would result in a reduction to the essentials, a return to the bare bones of the conquered subject. Today the avant-garde no longer uses depth panning and long shots but sound and the use of the new liberties of style to extend the boundaries of cinema. Jean Renoir alone gave us a

* Right after World War II, owning a Parker pen was an important status symbol.

masterly example of this in *The River* (1951). The man who was the precursor of this revolution in *The Rules of the Game* today proves to everyone where the reexamination of old categories of cutting leads: to the possibility of saying more with much less "cinema." Fidelity to *Citizen Kane* is seen in *Bicycle Thief* (De Sica, 1948) and *Diary of a Country Priest.* That is what Hitchcock has not understood—his evolution is exactly the opposite. *Shadow of a Doubt* was a dense and substantial work, filled with true mystery and a disturbing poetry, but the technique was still dependent on the story line.

From film to film we see technical feats multiply and become more acrobatic. In *Spellbound,* an eye fills the screen and its pupil becomes the mirror of the crime. In *Strangers on a Train,* there is some progress—we see the murder through the distorted reflection in the victim's glasses that have fallen to the ground.

The first twenty or twenty-five minutes of the latter film, however, are remarkable and the detective film concept is very clever. It is worthy of Graham Greene's good detective novels and certainly more consistent in the direction than Carol Reed's expressionism in *The Third Man* (1949). But from then on it is merely a matter of keeping us on the edge of our seats. For this, every means is a possible one for Hitchcock; he even returns to the old suspense of parallel editing, first used by Griffith in *Intolerance* and which is no longer used, even in B Westerns: a race against the clock between the criminal, who leaves to place the suspect's lighter at the scene of the crime, and the suspect himself, who is compelled to finish a championship tennis match before he can retrieve this compromising object. The match itself is sensational, but, in a process unworthy of a gentle-

man of the cinema, the editing parallels the concomi-
tant action. Between two volleys, we see the murderer
get rid of the lighter in a sewer grating.

Hitchcock's fans reproach me for ignoring the
man's cleverness and humor demonstrated here by the
very obviousness of the methods he uses in this film.
This is true. And it is also the ray of hope existing in this
work through which his least acceptable rhetoric sur-
passes itself and can become his alibi. We know that
Hitchcock has one idiosyncrasy: he appears in all his
films for a brief moment. In *Lifeboat,* he is seen in a
magazine photograph that is stained with oil and float-
ing among the wreckage of the ship. In *Strangers on a
Train,* we see him as a musician glimpsed boarding the
train with an enormous bass fiddle. We have to take this
as more than a superstition or a director's trademark. A
point of irony touching his entire oeuvre is the reminder
of a certain between-the-lines reading of the scenario by
those who can see beyond the most obvious effects.
Nonetheless, at times this marvelously oiled mecha-
nism grates strangely on one's ears. Through the rhetor-
ical, conventional, and, in a word, reassuring sadism of
American films, Hitchcock sometimes makes you hear,
over the victim's terrified screams, the true cry of joy
that does not deceive you—his own.

(*L'Observateur*—January 17, 1952)

Strangers on a Train

A new Hitchcock film is always an important event. This corpulent fellow with a clumsy silhouette is perhaps the most clever man in the movies. His departure for Hollywood in 1938 was undoubtedly a heavy loss for British films, whose renaissance would not have been so late in coming had the author of *The Thirty-Nine Steps* continued to work in the British studios. I am not sure if Hitchcock has not partly lost what Hollywood has gained. This extraordinary technician, capable of making his camera do whatever he wants (I am thinking in particular of *Rope,* filmed in ten shots of ten minutes each), has undoubtedly found means more appropriate to his scale in America. But, for as often happens over there, he has been categorized by the producers into doing the scripts best suited to what his style promised. He has become the emperor of the "psy-

chological detective film," of the mental thriller, of the three trigger suspense. No one knows better than he how to lead his audience by the nose, making it experience the exact dose of anticipated emotion at just the right moment.

But that doesn't say it all! A character is not a well-oiled machine that automatically reacts to an unchangeable mechanism of passions. All great detective works on some level transcend the simple detective interest. Whether it be Simenon or Graham Greene, their books contain mysteries other than that of the plot.

This film is particularly well orchestrated. A young husband wants to divorce his adulterous wife to marry the woman he loves, but the wife cynically refuses to do so. One day, on a train, he meets a strange character who proposes an ingenious deal: "Your wife is in your way; I hate my father. Since the motive is what usually gives the culprit away to the police, let's swap crimes: I'll make you a widower if you'll make me an orphan." The young man considers this offer the proposal of a fool or a black humorist—until the day he learns of the death of his wife, strangled in an amusement park—and until he begins to be blackmailed by his "accomplice." The scenario of a Hitchcock film is too intimately linked to the direction to be summarized. "It has to be seen."

If you like detective films, you will not regret seeing this one, despite my reservations. Everything is relative. Hitchcock has lost his humanity and his humor but has retained enough of them so that his films differ from run-of-the mill productions. A macabre irony, a more authentic cruelty than appears at first glance, and a certain audacity, even in its social satire,

sometimes make the machine squeak and remind the viewer that if he is afraid, it is not always in jest.

As always, under the thumb of a director like Hitchcock, the acting—by the stars (Farley Granger, Ruth Roman, and Robert Walker) as well as the supporting cast—is impeccable.

(January 10, 1952)

The Lady Vanishes

Since the war, Hitchcock's American success has almost obliterated his background and his British films. We have a tendency to think that his pre-Hollywood work was unimportant. But last year's revival of *The Thirty-Nine Steps* was all that was needed to put things back into their proper perspective. The screening of *The Lady Vanishes,* a detective comedy shot in 1938 but unavailable in France, absolutely confirms what we could see in *The Thirty-Nine Steps.*

A strange and pithy film in many respects, its vision, in 1952, is retrospectively prophetic—to a disquieting extent. This story of espionage in the Tyrol, which pits an intelligence service agent against the German counterespionage, constantly implies the advent of war. Was it really expected in 1938? Possibly so, but we seem to have forgotten that.

Like *The Thirty-Nine Steps, The Lady Vanishes* is primarily a scenario film and was written by Sidney Gilliat and Frank Launder, who have since written and directed films that rank among the most personal of British productions *(The Rake's Progress,* 1945, in particular). In this film we already find the essential characteristics of contemporary British comedy with perhaps less social realism (but is this really the best of the present school?) as well as more sour and biting humor. National self-criticism has never been pushed so far as Hitchcock has done in *The Lady Vanishes.* The present success of British film therefore does not spring from *Passport to Pimlico* (Henry Cornelius, 1948).

Somewhere in the Tyrol, passengers of various nationalities are detained in a mountain hotel by a snowstorm that has delayed their train. Notable among them are two Englishmen, who are returning to London to attend an important cricket match. Nothing else in all of Europe matters to them but this match. There are also a young woman, returning to England to marry a man she doesn't love; a young musicologist in search of folklore; and an aging English governess beginning her well-earned retirement. After a strange incident that could have cost the young woman's life, she and the old lady become friends. They sit opposite one another in the same train compartment. The young woman dozes for a few moments; when she awakens her companion has disappeared. She asks for an explanation from her neighbors, who seem astounded and tell her that she had always been alone. The remainder of the film is devoted to the young woman's desperate search, with the musicologist's help, to shed light on the mystery—which I will let the reader do. You need only

know that the other characters are a German professor of neurology, a magician, an English lawyer on a clandestine trip with his mistress, a nun who wears high heels, and various characters of lesser importance.

Three years later Hitchcock made *Shadow of a Doubt* in America. Aesthetically, the two styles of directing might be separated by ten years. All the dramatic themes dear to the author of *Notorious* had already appeared in his British films; but whereas he restricted himself to presenting them in the most classical editing style, in America he immediately turned himself into another director. If we were to calculate these facts, I would say that if we use the number one hundred to be the totality of what is said in any given film, in *The Thirty-Nine Steps* and *The Lady Vanishes,* seventy-five percent refer to the script and twenty-five percent to the directing—a proportion fairly close to what we could assign to the theater or to American comedies in 1936. Later on, Hitchcock's American works are written in cinematic terms. The script is integrated into the direction, as the content of a novel is to its writing. In England there are half a dozen directors who could make a film as good as Hitchcock's from the script of *The Thirty-Nine Steps;* but I am sure that not one of them could make *Strangers on a Train.* Is this to say that the American Hitchcock is superior to the British one? Theoretically he must be—just as the writer's or painter's art is superior to that of the theatrical director. How does it happen that, with the exception of two or three American films, I feel the opposite? Undoubtedly because the script does not warrant any technical tricks. A good script (I mean one which goes into detail of action and character) is almost a good film in itself.

The a priori preoccupation with directing is a temptation which Hitchcock can no longer resist, and the meaning of the script is the loser.

(*L'Observateur*—April 10, 1952)

I Confess

Of all the directors, Alfred Hitchcock stands out in mastering all the dramatic resources of cinematic directing and deploying them with the greatest virtuosity. All of this is evident in *I Confess*. If at first the film seems less brilliant than *Strangers on a Train* or *Notorious*, it is only that this time Hitchcock used more moderation, which does get in the way of the most precise technical work possible. On the contrary. Never by chance does a person "enter the frame" through his shadow or does the camera shoot at a slightly "low angle." No one knows better than this diabolical Englishman, who emigrated to Hollywood, how to charge his images with the tension necessary for his purpose. He organizes the interior relationships of these images along the unmarked strong lines of a malevolent field of vision which is always perfectly legible to the viewer.

This extreme science of the image is enhanced by the distinct knowledge of its effectiveness. There is never the least loss of dramatic energy in a Hitchcock film. The film plays on every viewer's nerves—whatever his age, temperament, intelligence, or culture. He gives us the sense of developed mechanisms, carried to such a degree of perfection, beyond which we can only calculate infinitesimal improvements.

Why, then, does *I Confess* disappoint us so much, often more, than Hitchcock's other films? Probably because this film acts upon the viewer's nervous system. Admittedly, Hitchcock carries us from the most sensitive nerve endings to the cerebral cortex. Through this channel he stimulates our intellect. The emotion, however, never goes beyond the cerebral sphere to the heart or, even more generally, enters the consciousness.

In this film he is clearly dealing with an ambitious subject on a high moral level and it is bound to be disturbing as it is based on the inviolability of secret confession. A young priest, Father Logan, receives the confession of his sexton who has just murdered a local lawyer. In committing this crime the murderer donned a cassock and a witness saw him leaving the lawyer's house. The inquest reveals that Father Logan held an interest in the lawyer's disappearance. The latter was blackmailing a young married woman who was formerly Father Logan's fiancée. The police, therefore, have every reason to suspect the one man who knows the real murderer's identity, but who will not avail himself of legitimate means of justification as he is bound by the secret of the confessional. Everything that the young woman who still loves him can say on his behalf will be used against him. And only the belated

remorse of the sexton's wife saves the condemned priest from being hanged.

We see that the sentimental and moral aspects of the script are not negligible. In fact, Hitchcock never uses them for himself but only as a function of a dramatic mechanism. Love or religious duty are for him only cogs and levers in his anguish-producing machine. But this treason contains its own approbation: so much science, which bypasses the essential, ends up engendering boredom. We want to like the characters and sympathize with them, instead of merely being interested in their problems and tolerating their mishaps.

Anne Baxter has changed considerably since *The Magnificent Ambersons* (1942). Her face has taken on a common harshness, but it is admirably used here and indeed serves the character well. Montgomery Clift as Father Logan is almost naïvely caught in the trap of his duty. His face registers very few expressions, but they are credible.

(July 2, 1952)

Dial M for Murder

Hitchcock's film, on more than one level, could be compared to Clouzot's *Diabolique*. Both films could be considered as "entertainments" with respect to their directors' more ambitious works—*I Confess* or *The Wages of Fear* (1953). In *Dial M for Murder*, the character of formal entertainment is given more emphasis by the fact that the film was shot in stereoscopic 3-D. I recently wrote (see *Radio-Cinéma*, no. 263, pp. 2–3) why the use of 3-D had been abandoned, even when it was a question of films shot by this method. As might have been expected, *Dial M for Murder* was also presented in a flat version (after *Phantom of the Rue Morgue*, 1954, or *Hondo*). It is a great pity because it would have been the first opportunity to see a 3-D film by a great director who is also a specialist in technical effects. But I must admit that the subject in no way evokes the third di-

mension and that, except for the murder scene and perhaps the trial, the film shown in its flat version loses nothing of vital interest.

It is the faithful adaptation of an English detective play. As in *Rope*, Hitchcock has respected the unity of place. The action develops in the apartment of the victim and the murderer. This film is in the best tradition of the English murder mystery and falls perfectly into four logical and dramatic periods. After he has found out that his wife has had an affair with one of their friends—a mystery story writer—the husband decides to get rid of her through a perfect crime. He devises a diabolical scheme that will allow him to have one of his former high school friends, whom he runs into by chance and about whom he has discovered some very embarrassing secrets, commit the actual murder. With his friend at his mercy, the husband offers to keep quiet and pay one thousand pounds if the friend will do his dirty work. The murder is to take place during a nocturnal telephone call, which the husband will make to his wife from his club. Everything is so perfectly prepared that the murderer, theoretically, risks nothing. Everything happens as planned—except for one minor detail, which is . . . the murderer gets killed as the victim was able to fend him off. Thus ends the second act, and we are led to believe that the husband has lost the game. But in the course of the inquest he manages to reverse the situation—not only does he avoid being a suspect but he even leads the police into deducing that his wife willfully killed the man who was threatening her with blackmail. And it is justice itself that will commit the crime—it will condemn her to hang. The fourth act is naturally devoted to reestab-

lishing the truth, thanks to the minute grain of sand that clogs the machinery and which I will not disclose to the reader.

This is an example of a good play, well done in a minor but standard genre. Hitchcock staged it with his usual skill. The directing of the actors is impeccable and all the effects work. The murder scene is particularly striking because the victim, wounded by a scissors' cut in the back, stumbles backward, killing himself when he falls . . . toward the audience, toward the camera placed in a hole in the floor. But the attempt at cinematic treatment is almost nil. A great deal of the action is alluded to orally, whereas there was nothing to prevent Hitchcock from visualizing it. We have to distinguish filmed theater in which the dialogue is the action (i.e., *Les Parents Terribles,* Cocteau, 1948, or even *Rope*), from that in which the dialogue alludes to the action. In the latter case, faithfulness to the theater is not justifiable. Also note that the principle of suspense is different here from that of *Diabolique* and of an inferior quality. The final truth actually rests on an important detail which has been hidden from us, whereas in Clouzot's film it is of a purely psychological nature.

(February 13, 1955)

Lifeboat

Paris is now seeing one of Hitchcock's most brilliant films. A film which was unknown to us: *Lifeboat*. Produced in 1943 and obviously based on a real-life story, this film should normally have been shown in France in 1946 or 1947. Why did it stay on the American distributor's shelf? Is it because everything about the script or the dialogue that might now seem a bit dated might have seemed dated back in 1946? But for God's sake, Americans have not been embarrassed to bring us, even after a delay of a number of years, war films whose ideology was much more infantile and superficial than this one. It is most likely that *Lifeboat* suffered from its controversial script as well as its directing. Hitchcock took one of the greatest risks of his career with this film, if we exclude *Rope*.

All the action takes place in a lifeboat, where eight

survivors find themselves after their freighter has been torpedoed. With them is the commander of the German submarine that also sank. Considering their social backgrounds, personalities, professions, hopes, and also physical states (one of them was wounded in the leg, which will become gangrenous), how will these people react to one another and to danger? Above all, how will these Americans behave toward the German responsible for their misfortune? The action revolves—or rather crystallizes—around this particular character. This Nazi proves to be the most competent person to deal with everyone's needs. As he was a surgeon in civilian life, he is able to operate on the wounded man. As he is a naval officer, he is the only one capable of sailing the lifeboat under risky conditions.

Despite their aversion, the shipwrecked passengers are obliged to trust him. Because of his technical knowledge, the prisoner becomes their jailer. He takes advantage of this to steer the craft not toward the coast, as he had initially alleged, but toward the site where he knows he can find the German parent ship. When the passengers confront him with this, he argues that they had no chance to reach the Hebrides and that it would be better for them to be prisoners than corpses in a drifting boat. The argument is technically valid, and they give in. But when supplies and water run low and there is no sign of the parent ship, the German, who had saved the wounded man's life by amputating his leg, does not hesitate now to throw him overboard—as much to alleviate his sufferings as to eliminate a useless mouth. This time he's gone too far, and the passengers decide to kill their prisoner.

Thus is symbolized the wrath of justice, which

must finally overcome pragmatic Anglo-Saxon liberalism—in other words, war. Moreover, I think that one would find in all American war films an implicit rhetoric aimed at the same goal. Yet rare were the productions where this rhetoric was better developed. Given these ideological ends, it would be difficult to find someone more skillful than Hitchcock. These ideological ends are there, however, and prevent me from really concentrating on the story.

But even in the most stringent hypothesis with respect to its apologetic aspects, the film remains quite admirable. If the woof is civic and political, the warp is purely psychological and moral. The relationships between the characters correspond actually to two systems of coordinates, one of which owes nothing to historical contingencies. I can easily imagine *Lifeboat* without its sound track. We would then ascribe to the characters and events motivations and causes stripped of any ideology. I think that seen in this way the film would be almost perfect. It is enough to say that, basically, its qualities reside in the directing in the sense that it forms the very substance of the work.

(*L'Observateur*—June 14, 1956)

Hitchcocks vs. Hitchcock

I trust that the following account of my encounter with Alfred Hitchcock will not disappoint his wildest partisans. They may accuse me of being unworthy of the privilege of confirming all their insights. Certainly, where I am in doubt, I would prefer to give them the benefit of that doubt. I cannot say that the combined efforts of Schérer, Astruc, Rivette, and Truffaut have entirely convinced me of Alfred Hitchcock's flawless genius, particularly in his American work, but they have at least persuaded me to question my previous skepticism. Consequently, I can report that I approached my assignment in good faith and a constructive spirit by conscientiously assuming the point of view most favorable to the director and by insisting on his recognizing for himself and by himself every last morsel of meaning French critics had assigned to his films.

Moreover, I would have been delighted if his answers had vindicated his champions and if the reservations I had formulated about such works as *Rope, The Paradine Case,* and *I Confess* had been reduced to rubble.

Before going any further, however, I propose some critical axioms, which the Hitchcockians may scorn as useless and undignified alibis.

I will begin with an embarrassingly personal anecdote. Once upon a time I analyzed a certain scene in *The Little Foxes,* the one in which Herbert Marshall is seen about to die on the stairway, in the background, while Bette Davis sits immobile in the foreground. The fixed gaze of the camera seemed to me to be intensified (moreover, if I remember correctly, the remark came from Denis Marion) by the fact that in the course of his movement the actor moved out of the frame and then came in again a little farther away, while the lens—identified somehow with Bette Davis's implacability—did not deign to follow him.

When I attended the Brussels Festival in 1948, I had the opportunity of meeting William Wyler, whose native language is French, and I explained my interpretation to him. Wyler seemed astonished. He insisted he had done everything quite simply with no intellectual premeditation. As for my crucial point about Marshall's departure from the field of vision, Wyler explained the specific reason: Marshall had a wooden leg and had difficulty climbing stairs; his eclipse permitted a double to be substituted for the last few seconds of the scene.

The anecdote was too funny to ignore even though the joke was on me. I reported it in my article on *Roman Holiday,* in *L'Ecran français* under the collective signature

of the Minotaur and held my ground as far as my initial analysis was concerned. My candor was rewarded with an ironic letter about *critics of Spanish inns* from some sly type reminding me of the Minotaur's note which I was forced to ignore in order to continue to ascribe to Wyler aesthetic calculations, a hypothesis that he himself had demolished.

I have verified the truth of this edifying story on several other occasions. There are, occasionally, good directors, like René Clément or Lattuada, who profess a precise aesthetic consciousness and accept a discussion on this level, but most of their colleagues react to aesthetic analysis with an attitude ranging from astonishment to irritation. Moreover, the astonishment is perfectly sincere and comprehensible. As for the irritation, this often springs from an instinctive resistance to the dismantling of a mechanism whose purpose is to create an illusion, and only mediocrities gain, in effect, from malfunctioning mechanisms. The director's irritation springs also from his resentment at being placed in a position that is foreign to him. Thus, I have seen a director as intelligent (and conscious) as Jean Grémillon play the village idiot and sabotage my debate on his *Lumière d'Eté* evidently because he did not agree with me. And how can I say he is wrong? Is not this impasse reminiscent of Paul Valéry's leaving the lecture hall where Gustave Cohen had presented his famous commentary on *Cimetière Marin (The Graveyard by the Sea)* with a word of ironic admiration for the professor's imagination? Must we conclude then that Paul Valéry is only an intuitive artist betrayed by a pedant's textual analysis and that *Graveyard by the Sea* is merely automatic writing?

As a matter of fact, this apparent contradiction between the critic and the author should not trouble us. It is in the natural order of things, both subjectively and objectively.

Subjectively, because artistic creation—even with the most intellectual temperament—is essentially intuitive and practical: it is a matter of effects to attain and materials to conquer. Objectively, because a work of art escapes its creator and goes beyond his conscious intentions, in direct proportion to its quality. The foundation of this objectivity also resides in the psychology of the creation to the extent—inappreciable—to which the artist does not really create but sets himself to crystallize, to order the sociological forces and the technical conditions into which he is thrust. This is particularly true of American films in which you often find quasi-anonymous successes whose merit reflects, not the director, but the production system. But an objective criticism, methodically ignoring "intentions," is as applicable to the most personal work imaginable, like a poem or a picture, for example.

This does not mean that knowing *auteurs* personally, or what they say about themselves and their work, may not clarify the critic's conception, and this is proven by recently taped interviews that we have published. These confidences, on the contrary, are infinitely precious, but they are not on the same plane as the criticism I am discussing; or, if you will, they constitute a precritical, unrefined documentation, and the critic still retains the liberty of interpretation. Thus, when Wyler told me he had had Marshall leave the field of vision merely in order to substitute a double, I thought to myself that the flaws in the marble were useful only

to good sculptors and that it was of little importance that the camera's fixity was imagined to come out of a technical contingency. But the following day, when I saw Wyler again, it was he who returned to the subject and explained to me that Marshall's going out of the frame was not part of his artistic intentions and that, in turn, the light and soft quality of the background (the stairway where Marshall is dying) had been asked of Gregg Toland in order to create an uneasy feeling in the spectator by the imprecision of the action's essential point. In this context, virtually the entire film was shot in deep focus. Quite possibly, the softness and the disappearance had the same function: to camouflage the substitution of the double for the actor. In the case of the softness, the director was conscious of the effect and the means, which sufficed to elevate material servitude to the dignity of artistic windfall. Unless, profoundly astonished that so many things could be seen in this unfortunate sequence, he dreamed it up during the night and, when he woke up the next morning, was retrospectively persuaded that he had done it on purpose. It is of no real importance in terms of Wyler's glory and the excellence of *The Little Foxes,* but I am more partial to this explanation than to my original interpretation.

I make the foregoing observations in order to reassure and encourage those who, in this same issue of *Cahiers du Cinéma* (no. 39, October 1954), will credit Alfred Hitchcock with more talent than is implied in this interview. I am also perfectly conscious of not having pushed the *auteur* of *The Lady Vanishes* to a point where I could get past his defenses. Also the relatively serious nature of my questions undoubtedly had little

in common with what he was accustomed to in American interviews, and the sudden change in critical climate may have upset him. Besides, people say that his answers tend more to mask than to reveal, and his penchant for straight-faced jesting is familiar enough to lend credence to this interpretation.

But now that I have raised every possible objection against my interviews with Hitchcock, I might well add that I am personally convinced of my interlocutor's sincerity, and I do not suspect for a moment that he accommodated my questions in order that I might judge his work less severely.

We met the first time at the flower market in Nice. They were shooting a scuffle. Cary Grant was fighting with two or three ruffians and rolling on the ground under some pink flowers. I had been watching for a good hour, during which time Hitchcock did not have to intervene more than twice; settled in his armchair, he gave the impression of being prodigiously bored and of musing about something completely different. His assistants, however, were handling the scene, and Cary Grant himself was explaining Nice police judo techniques to his partners with admirable precision. The sequence was repeated three or four times in my presence before being judged satisfactory, after which they were to prepare to shoot the following sequence in an insert in close-up of Cary Grant's head under the avalanche of pink flowers. It was during this pause that Paul Feyder, French first assistant on the film, presented me to Hitchcock. Our conversation lasted fifty or sixty minutes (there were retakes) during which time

Hitchcock did no more than throw one or two sick glances at what was going on. When I saw him finally get up and go over for an earnest talk with the star and the assistants, I assumed that here at last was a matter of some delicate adjustment of the mise-en-scène; a minute later he came toward me shaking his head, pointing to his wristwatch, and I thought he was trying to tell me that there was no longer enough light for color—the sun being quite low. But he quickly disabused me of that idea with a very English smile: "Oh! No, the light is excellent, but Mister Cary Grant's contract calls for stopping at six o'clock; it is six o'clock exactly, so we will retake the sequence tomorrow." In the course of that first interview I had time to pose nearly all of the questions I had had in mind, but the answers had been so disconcerting that, full of caution, I decided to use a counterinterrogation as a control for some of the most delicate points. Most gracefully, Hitchcock devoted another hour to me several days later in a quiet corner of the Carlton Hotel in Cannes. What follows comes out of these two interviews without, in general, any distinction between what was in the first or the second.

I must make it clear at the outset that I speak and understand English too poorly to manage without an interpreter. I had the good fortune to find in Sylvette Baudrot, French scriptgirl with the crew, more than a faithful dragoman, a persistent collaborator. I take this opportunity to thank her cordially.

I began in more or less these terms: "While traditional criticism often reproaches you for brilliant but gratuitous formalism, several young French critics, on the contrary, profess a nearly universal admiration for

your work and discover, beyond the detective story, a constant and profound message. What do you think about that?"

Answer: "I am interested not so much in the stories I tell as in the means of telling them." There followed a long account of *Rear Window* in terms of the technical improvisations that gave the film its originality. The film takes us, once more, into the realm of the detective story. The investigation is conducted in this instance by a convalescing magazine photographer, obliged to stay in his room because his leg is in a cast. He is also to discover a crime and identify the criminal solely by observing the comings and goings through the windows of the apartment building across the courtyard. During the entire film the camera remains in the journalist's room and sees only what he can physically see, either with the naked eye or with the aid of binoculars, which in any event allows for the use of different lenses. Telescopic lenses were ultimately required to keep the action in some sort of meaningful dramatic focus. The construction of the set posed equally complicated problems in order to permit the protagonist to observe as much as possible of his neighbors' actions *without faking the architecture of an American city.* Hitchcock himself insisted that half the film's action should be silent because the journalist cannot be expected to hear his neighbors at the distance he sees them. Thus the director had to resort to the guile of "pure cinema," which he adores. In general, dialogue is a nuisance to him because it restricts cinematographic expression, and he reproaches several of his films for this restriction.

At this point I did not abandon the point of my original inquiry by taking up the fallacious opposition

of form and content. What Hitchcock calls "means" may be, perhaps, only a more indirect (and more unconscious) manner of following, if not a subject, at least a theme. I stressed, therefore, the unity of his work, and he agreed with me in a negative way. All he demands of a script is that it go his "way." Let's see if I can dig further. What I wanted was the exact definition of this "way." Without hesitation, Hitchcock spoke of a certain relationship between drama and comedy. The only films that may be taken as "pure Hitchcock" [sic] are those in which he has been able to play with this discordant relationship. Although this seems to be more a matter of the way of conceiving a story than content, it is, all the same, no longer a question of simple formal problems. I venture the word "humor." Hitchcock accepts it; what he is trying to express may well be taken as a form of humor and he spontaneously cites *The Lady Vanishes* as conforming most closely to his ideal. Must we conclude from this that his English work is more "purely Hitchcock" than his American? Without a doubt, first of all because the Americans have much too positive a spirit to accept humor. He could never have made *The Lady Vanishes* in Hollywood; a simple reading of the script and the producer would have pointed out how unrealistic it would be to send a message with an old woman by train when it would be quicker and surer to send a telegram. He thought he would please his old Italian maid by asking her to see *The Bicycle Thief,* but all she felt was astonishment that the worker did not manage a bike: America is rapidly becoming less colorful. Moreover, in Hollywood films are made for women; it is toward their sentimental taste that scenarios are directed because it is they who

account for the bulk of the box-office receipts. In England films are still made for men, but that is also why so many studios close down. The English cinema has excellent technicians but English films are not "commercial" enough, and Hitchcock declares, with pain mixed with shame, that they are idle there while he is working. But it is still essential for a film to bring in more than it costs; the director is responsible for other people's money, a great deal of money, and he has a duty, in spite of everything, to be commercial. Hitchcock told me that his "weakness" lies in being conscious of his responsibility for all this money.

What I am inserting here is parenthetical: At the time of our second interview, the question came up again. Hitchcock appeared to me to be somewhat conventionally concerned with correcting that indirect criticism of being commercial by affirming that it was easy to make an "artistic" film, but the real difficulty lay in making a good commercial film, a very feasible paradox, after all. Such as it was, the sense of his first self-criticism was unequivocal and the necessity of renouncing adult, masculine humor in order to satisfy American producers was presented as an exquisite torture. When he arrived from England, and saw the technicians standing in line with their lunch boxes, under the clock, at the door of Warner Brothers, he anxiously asked himself if, in all this hub-bub, film could possibly still be concerned with a form of the fine arts.

Faithful to my role of devil's advocate, I remarked that, in the Hollywood studios, perhaps he had gained lavish technical means that suited his inspiration. Had he not always been concerned with ingenious and sometimes complex technical effects in order to obtain

certain effects of mise-en-scène? Categorical answer: The importance of the technical means placed at his disposal did not particularly interest him, they rendered the film more costly and they even augmented commercial servitude. To sum it up, his ideal is, under those conditions, to accomplish perfection of "the quality of imperfection." This rather oracular line was one of those about which I was determined to see Hitchcock again to pin him down to a more precise confirmation. My interpreter, Hitchcock, and I spent a good quarter of an hour on this one point. He maintained what he had said and commented on it, but it never became perfectly clear. His exact words, in English, were, "I try to achieve the quality of imperfection." I believe I understood that the quality in question was American technical perfection (lacking in the European cinema) and the "imperfection" that margin for liberty, imprecision and, shall we say, humor that makes, for Hitchcock, the English cinéaste's position superior. Thus it is a question for the director of *I Confess* of achieving the almost impossible marriage of perfect technical execution through Hollywood's oiled and supple machinery with the creative stumbling block, the unforeseen Acts of God, as in the European cinema. I am paraphrasing here and forcing myself to give a résumé of a conversation that, as far as I can see, was persistently obscure due to my lack of intellectual agility with the English language but also, I strongly believe, due to Hitchcock's instinctive irony. For I noticed several times his taste for the elegant and ambiguous formulation that goes so far as to become a play on words. Chabrol became aware of this tendency several times in Paris when Hitchcock made theological jokes

based on "God" and "Good." This linguistic play-fulness assuredly corresponds to a cast of mind but undoubtedly it is also a certain form of intellectual camouflage. For all that, I did not have the impression that this preoccupation affected our dialogue more than marginally. In general, the answers were clear, firm, and categorical. The circumstances were rare when, whether to correct the excessiveness of an affir-mation that was a little too scandalous or paradoxical, or the question was particularly embarrassing, he used this sort of critical humor to rectify something or to pirouette his way out of a statement. The general sin-cerity of his answers and, I even dare to say, up to a certain point, their naïveté (if I am not misjudging how much is bravado and how much paradox) was indi-rectly proven to me by his reaction to one of my argu-ments. Always pursuing my initial purpose of having him recognize the existence and the seriousness of a moral theme in his work, I decided, in default of obtain-ing an acknowledgment from him, to suggest one my-self, borrowing for this the perspicacity of the fanatic Hitchcockians. Thus, I had him notice that one theme at least reappeared in his major films that, because of its moral and intellectual level, surely went beyond the scope of simple "suspense"—that of the identification of the weak with the strong, whether it be in the guise of deliberate moral seduction as in *Shadow of a Doubt,* where the phenomenon is underlined by the fact that the niece and the uncle have the same name; whether, as in *Strangers on a Train,* an individual somehow steals the protagonist's mental crime, appropriates it for himself, commits it, and then comes to demand that the same be done for him, whether, as in *I Confess,* this transfer of

personality finds a sort of theological confirmation in the rite of penitence, the murderer considering more or less consciously that the confession not only binds the priest as witness but somehow justifies his acceptance of the guilty role. The translation of such a subtle argument was not very easy. Hitchcock listened to it with attention and intensity. When he finally understood it I saw him moved, for the first and only time in the interview, by an unforeseen and unforeseeable idea. I had found the crack in that humorous armor. He broke into a delightful smile, and I could follow his train of thought by the expression on his face as he reflected and discovered for himself with satisfaction the confirmation in the scenarios of *Rear Window* and *To Catch a Thief.* It was the only incontrovertible point made by Hitchcock's enthusiasts, but if this theme really exists in his work he owes it to them for having discovered it.

However, I did not dwell on it very long and the self-criticism that he pursued was rather severe. *I Confess,* for example, was rejected for its lack of humor—the comedy was not in step with the drama. He is no longer enchanted with the players. Anne Baxter is an excellent actress but her looks do not fit into Canadian society. He would have liked Anita Bjork, whom he greatly admired in *Miss Julie,* but Hollywood had been scared off by her extramarital entanglements (Ingrid Bergman's troubles still lingered in the studio's memory).

In opposition to this I remarked that he had, however, held on to this subject, taken from a little-known French boulevard play, given to him four years earlier by Louis Verneuil ("sold," he corrected). If he had not shot it before, he explained, it was only because Warners was afraid of censorship; there was thus nothing

mysterious about the delay. Good; but must we not assume that the films he produced would have a hold on his heart? Not at all, notably *Under Capricorn,* which, in spite of its failure, had been principally a commercial enterprise. All of his efforts to save something from this film were in vain. Hitchcock complained that because of her fame Ingrid Bergman was no longer easy to work with. "All the same," I said, "the brilliant sequences, continuous in time, that called for the utmost in technical experience, in *Rope*—" "Let us talk about that!" he interrupted. "These continuous scenes were boring enough later during the editing; there was nothing to cut!"

However, coming back to *I Confess,* I obtained an important concession. When I praised the extreme technical sobriety, the intensity in austerity, it was not in order to displease him. It is true that he applied himself here and that the film finds favor in his eyes for these formal reasons. In order to characterize this rigor of directing and stage setting it would be necessary to employ an epithet from the "clerical vocabulary." I suggested "Jansenist." "What is a Jansenist?" Sylvette Baudrot explained to him that the Jansenists were the enemies of the Jesuits. He found the coincidence very funny for he had studied with Fathers and, for *I Confess,* had been obliged to free himself from his education! I did not tell him I would have thought him, nevertheless, a better student. At least in theology.

Which, then, at least among his American films did he consider to be the most exclusively commercial and the least worthy of esteem? *Spellbound* and *Notorious.* Those that found grace in his eyes? *Shadow of a Doubt* and *Rear Window.*

We have already spoken of the last one. What, in particular, does he like in the first? The truth, the social and psychological realism, in the framework, naturally, of the dramatic humor we have already defined. He was able to avoid the concessions and commercial "fantasies" that more or less debased his other American films.

The interview came to an end, not because my interlocutor had the air of becoming impatient, but because I could see no way to bring the debate back to the essential. I come now to the formal and secondary questions: Is it true that he never looked through the camera exactly right? This task is completely useless since all the framing has been planned and indicated in advance by little drawings that illustrated the cutting technique. At my request he immediately executed several. If I may, I will add a personal comment here: it seemed to me, as much from certain precise points made in the conversation as from statements gathered from Hitchcock's collaborators, that he had a permanent notion of mise-en-scène, that of a tension in the interior of a sequence. A tension that one would not know how to reduce either to dramatic categories or plastic categories but which partakes of both at the same time. For him it is always a question of creating in the mise-en-scène, starting from the scenario, but mainly by the expressionism of the framing, the lighting, or the relation of the characters to the decor, an essential instability of image. Each shot is thus, for him, like a menace or at least an anxious waiting. From German Expressionism, to whose influence he admits having submitted in the studios in Munich, he undoubtedly learned a lesson, but he does not cheat the

spectator. We need not be aware of a vagueness of impression in the threats in order to appreciate the dramatic anguish of Hitchcock's characters. It is not a question of a mysterious "atmosphere" out of which all the perils can come like a storm, but of a disequilibrium comparable to that of a heavy mass of steel beginning to slide down too sharp an incline, about which one could easily calculate the future acceleration. The mise-en-scène would then be the art of showing reality only in those moments when a plumb line dropped from the dramatic center of gravity is about to leave the supporting polygon, scorning the initial commotion as well as the final fracas of the fall. As for me, I see the key to Hitchcock's style, this style that is so indisputable that one recognizes at a glance the most banal still from one of his films, in the admirably determined quality of this disequilibrium.

One more question to get off my conscience, the answer to which is easy to predict: Does he use any improvisation on the set? None at all; he had *To Catch a Thief* in his mind, complete, for two months. That is why I saw him so relaxed while "working." Moreover, he added with an amiable smile, lifting the siege, how would he have been able to devote a whole hour to me right in the middle of shooting if he had to think about his film at the same time?

It was a charming way to end our conversation.

(*Cahiers du Cinéma*—October 1954)

To Catch a Thief

During conversations I had with Hitchcock when he was shooting a film on the Côte d'Azur and Provence, he did not conceal the fact that he considered *To Catch a Thief* a commercial film in which he only made use of his expertise and nothing more. One might take this remark with a grain of salt, however. This said, if *To Catch a Thief* is not on the same level as *Rear Window* or *I Confess,* the film is more than mere entertainment. *To Catch a Thief* is a remarkable film, and in it Alfred Hitchcock has managed to surpass himself. His favorite themes, which the young Hitchcock-Hawksian French critics seem to have revealed to him, are very much in evidence here. Despite his claim of not having gotten deeply involved in this film, Hitchcock's themes, treated in a relatively formal and externalized way, are clearly stated—especially the primary one, which Fran-

çois Truffaut has extricated in a fairly irrefutable way: that of the identification of one character with another, a kind of ontological identification which is the ulterior motive for the action.

Judge for yourselves. A former agile burglar called "the Cat," a specialist in jewel thefts, has wised up after being "redeemed by the Resistance." His life would still be peaceful if some recent crimes, committed in his style, had not made the police suspect that the Cat had returned. Arrested, but allowed temporary freedom, our man has ten days in which to prove his innocence by finding the plagiarist. He manages to do so by obtaining from an insurance agent a list of the richest bejeweled old ladies presently on the Côte and guessing which one of them his imitator will choose next. I will not, rest assured, divulge the key to the mystery. You will perhaps discover in due course, if you are shrewd enough to spot the right clue, who, among the characters surrounding Cary Grant, is simultaneously his double and his equal.

But aside from this detail emanating from the direction, I can reveal another. In Nice, Hitchcock had told me about a scene of which he seemed very proud. Cary Grant visits Grace Kelly in her room at the Carlton Hotel one evening under the pretext of being able to get a better look at a fireworks display over the ocean. Things develop as one would imagine. But as the American censors forbade showing anything explicit, Hitchcock faded from a kiss to the fireworks finale. I admit having thought to myself that the allusion was not subtle enough to justify the director's jubilation. I even found it fairly bad and think that our Hitchcock-Hawksians really had to hit rock bottom to find it inspired.

The sequence is in fact sensational—but for a reason that Hitchcock did not mention and which perhaps he did not even know how to express logically, as it is integrated with the visual content of the image he must have had in mind. Grace Kelly intends to seduce Cary Grant with her jewels. She forces him to caress the diamond necklace she is wearing. The whole scene is extraordinarily erotic and is based upon the ambiguity of desire aroused in the hero. During the entire beginning of the scene, the rockets we see bursting in the sky are therefore the allusive symbols not of sexual excitement, but of the blaze of the jewels. It is only little by little that the fireworks take on an erotic symbolism that coincides with Cary Grant's transfer of desire.

If the meaning of these pyrotechnical images is no longer ambiguous, it is perhaps because the implied action no longer needs it. Obviously my comments cannot describe what the eye alone understands, namely, the visual wealth of the images, which are incapable of conveying the subtlety of an idea in its very elementary form if it were not restored to its intellectual virginity as a consequence of the production.

To be sure, verisimilitude is by no means the strength of this scenario. In order to allow himself some flexibility with the plot, Hitchcock counted on the Anglo-Saxon ignorance of French manners and customs. Quiche Lorraine, for example, is not a specialty of southern France. Nor would the French police (alas!) so easily allow temporary freedom to a run-of-the-mill suspect. But it would be very masochistic to linger over this because these unimportant liberties serve to justify situations with penetrating humor.

A final remark. Even though half the actors are French—or precisely because of this reason—it would

naturally be better to see *To Catch a Thief* in its original version. But if in spite of everything you insist on seeing the dubbed version, at least see it where you have the advantage of wide-screen projection. There is better definition on the wide screen than on a standard one.

(*L'Observateur*—December 29, 1955)

Rear Window

R*ear Window* is undoubtedly Alfred Hitchcock's most technically perfect and ingenious film. Even the continuity of the takes in *Rope* does not constitute a feat comparable to the variety of technical difficulties Hitchcock resolves here. The basic idea of this scenario is that the staging is subdivided into a series of technical problems relating to set construction, shooting, and sound.

A famous magazine photographer, immobilized because his leg is in a cast, is sitting in his New York apartment where he will have to stay until he is able to travel again. This temporary infirmity leaves him at the charming mercy of his fiancée, who tries to convince him to abandon adventure and marry her. However, her frequent visits do not sufficiently distract the reporter from the numerous sights he can see in the oppo-

site apartments. It is very hot and the windows are always open. If peeping into the lives and characters of neighbors across the way is not a very respectable occupation, it is a fascinating one. We observe an old childless couple, who has trained its little dog to go down two floors in a basket he uses as an elevator so he can piddle in the courtyard; a pianist disappointed in love, drowns his memories in alcohol; a miss lonely hearts, who organizes dinners for two at which she is also the guest; then there is a young married couple whose curtains are always drawn and whose lights are always on; a dancer and model, whose gymnastic frolics in her abbreviated outfit offer an entertaining sight. Finally, there is a traveling salesman, who nurses his shrewish wife with abject devotion. The latter feigns sickness to annoy her husband all the more. The intrigue begins with this couple. One night the reporter observes the salesman repeatedly leaving his apartment with an aluminum suitcase. These curious comings and goings are inexplicable. The next morning the wife's window remains shut and the man is busying himself with some strange-looking housecleaning. Obviously, the wife is no longer there. Our amateur detective deduces that she has been murdered and dismembered by her husband. Then again, she might have simply gone off on a trip. In fact, after an investigation, that is the conclusion of a professional detective, who is a friend of the reporter. This conclusion satisfies neither our hero nor his fiancée, who is slowly becoming attracted by the mystery.

It is useless to reveal any more. This brief summary lets me make my critique without spoiling the plot. Although this is not a detective film in the style of

Diabolique, one can see *Rear Window* again and again, even when one knows the denouement.

Hitchcock conceived the scenario and shot the film from his hero's point of view. The direction only allows us to see or hear what James Stewart perceives from his wheelchair. This is not, however, a "first person" film or even a subjective one. The point of view is logical and physical. We are beside James Stewart, not in him. The ingenuity of the mystery therefore rests on the difficulty he has reconstructing the motives and methods of a crime through distant and extraordinarily fragmented observations. To make the events believable and simultaneously to permit the many allusions to the collective life of the building as seen through the other windows, Hitchcock constructed a rather elaborate set that is both remarkably realistic and in which all the clues are cunningly thought out. For example, the street glimpsed through the gap between two walls. It would have been unbearable to perceive only the unaware protagonists from the actual distance of the two façades. It was necessary to be able to vary the framing of the shots without actually going into the neighbors' apartments or cheating on the initial postulate. Hitchcock got around this through a very ingenious technical idea. James Stewart's profession entitles him to have a pair of strong binoculars and even an enormous telephoto lens adaptable to a "reflex" camera. Thus the changes in lenses, even the close-up shots, can be justified logically.

The use of color is equally splendid, be it in impressive dramatic effects (for example, when in the

darkened room the murderer's presence is indicated only by the reddish glow of his cigarette and the reflection of his glasses), or even in the structure of the script. James Stewart deduces that the body was buried in the courtyard by comparing the color of a zinnia at the end of a row to that of the flower appearing in the same place on a color slide taken a few days earlier from his window.

Furthermore, from his observation point, James Stewart can only see, not hear. Therefore a whole portion of the film is silent. The dialogue must be reconstructed from gestures and postures. We manage to do this quite well. The sound has not, however, been totally eliminated. Although we cannot understand specific words, they still reach us through muffled sounds and intonations. A sonorous hum, meticulously realistic, adds an auditory dimension to the delimited scenery.

Rear Window has, over and above any dramatic interest, a cinematic architecture of such complexity and subtlety that it commands one's admiration.

But it remains to be seen if the work in itself is worthy of all the difficulties Hitchcock had to overcome.

In spite of the eloquence and tenacity of the new "Hitchcock-Hawksian" criticism, I confess to being far from liking everything about this dazzling film. I can recognize some very convincing elements. The script can be subdivided into three themes that are intimately interwoven but yet distinct. The sexual theme: that of the relationship between Grace Kelly, a pretty and in-

telligent woman, madly in love, and James Stewart who, without scorning this prize, obstinately refuses to let himself "fall into her clutches." Their relationship has to be treated in an allusive manner but in such a way that its exact physical and psychological nature leaves no doubt in one's mind. With a stubbornness bordering on the intolerable, Grace Kelly immodestly offers herself to a man who thinks that the inconvenience of his cast and the nuisances of marriage are interfering with his wish to play at being a detective. This constitutes true daring whose erotic authenticity is unmatched in any American film. Two chords on this theme are struck again in the secondary characters: the exhibitionistic dancer and the insatiable couple.

I will qualify the second theme as unanimistic. I am speaking of the partial biographies of the characters observed in their various apartments. This is the most disappointing aspect of the film. The bravura here is most evident but most irritating. It is also one which, as opposed to the preceding theme, makes the most concessions to the Hollywood mythology of social behavior. We sense the desire to weave cleverly together a series of brilliant little sketches synchronized with the general unfolding of the plot. At the end of the film, we know everything about the past and future of these characters whom we have merely glimpsed. Nothing is kept in the dark, not even what might be ambiguous due to missing information. We aspire as if for a breath of fresh air to *not* knowing something about someone, to be left in doubt, which would allow these characters to have an existence beyond the scenario of the film.

As for the detective theme, it is a standard one, only its presentation breathes new life into it. One cannot but admire its treatment. The poisoning of the little dog, which had become an annoying witness from the time he scratched at the ground in the courtyard, is an extremely ingenious example. We find ourselves faced with a double objective. One is explicit and allows for quite an emotional scene when the dog's mistress discovers its dead body. The other aim is indirect and appears only upon reflection. Up until now the salesman has seemed more pitiful than hateful to us, and James Stewart has the role of bad guy in playing the vigilante. We are ready to forgive the poor man for ridding himself of such a bad-tempered woman. It was necessary for the proper psychological direction of the script that the detective become sympathetic again and that the "criminal" no longer gain through prejudice. It is the killing of the little dog that allows the viewer to be upset, while the dismemberment of a woman caused no such feeling.

There are, then, in *Rear Window,* three films in one. The story of the sexual relationship between a man and a woman is excellent; there is a resourceful but standard detective thriller; and finally there is a film containing sketches that are too cleverly constructed for one to believe in its characters. Their superimposition undoubtedly constitutes a more than respectable work, but it is nevertheless impossible to find candor. The film might have gone beyond the level of entertainment to that of first rate.

The Man Who Knew Too Much —1956*

I have never been able to share with some of my colleagues, and friends, in their unqualified admiration for Hitchcock. I do, however, recognize that their tenacity and the ingenuity of their analyses have certainly conquered some of my reservations with regard to his work. His ambitious films, such as *I Confess* or *Rear Window,* still do not manage to enthrall me in spite of the admiration I have for them. But works of pure entertainment, like *To Catch a Thief, The Trouble with Harry,* or this *Man Who Knew Too Much,* send me into euphoria. Could it be that something is missing in the

* Although Bazin does not mention it, this is the remake of Hitchcock's earlier film by the same title, made in England in 1934.

former, whereas the latter give more than they promise? Hitchcock has often declared—and not just to me—that he is only interested in how to tell a story. I make allowances for humor and the masque, but what is interesting about Hitchcock is precisely that, with him, form becomes the actual backbone of the narrative. It is not merely a way of telling a story, but a kind of a priori vision of the universe, a predestination of the world for certain dramatic connections.

With this in mind one can conceive of a Hitchcockian metaphysic, albeit completely implicit and indirect. It is allowed free rein only when it does not illustrate anything metaphysical in the script and when it is a game of forms and structures that have no link to psychology or sociology. Hitchcock excels at delicate characterization. One finds a touch of the elegant Lubitsch about him, with a British touch. This light realism, precise and yet somewhat abstract, serves only as the counterpoint and the basis for the metaphysical universality of structures. I will give an example of this a bit farther on. Let me conclude for the moment that Hitchcock is more serious than he will admit; yet he is less serious than he leads us to believe.

The Man Who Knew Too Much has much in common with Hitchcock's British scripts, like *The Thirty-Nine Steps*, not just because the theme is espionage but especially because of the deliberate improbability of the givens of the problem. This time the film concerns the misadventures of an American couple (James Stewart and Doris Day) who are on vacation in Marrakesh. By mistake they become involved in a battle between a French counterespionage agent (Daniel Gelin) and a couple of Englishmen in the employ of a mysterious

foreign power. The Englishmen have come to Morocco to recruit a hired killer to assassinate the prime minister during a concert at London's Albert Hall. It is never a good idea to be in on a state secret, albeit peripherally. In order to assure their silence, the traitors kidnap the Americans' child. Although forced to keep quiet, they will try to find their little boy in England before the attempted assassination takes place.

They unearth the kidnappers posing as priests in a neighborhood church. But not fast enough to prevent the boy from being transferred to the cellar of the mysterious embassy, and the killer from sitting in a loge at the Albert Hall, in an unobstructed position for the assassination. The last part of the film is devoted to masterly "suspenses": the first suspense is derived from the attempted crime at the concert (the killer must shoot at a precise moment during the score in order to camouflage the gunshot by the clash of cymbals); the second is related to the recovery of the child during a reception at the embassy.

Had I extended this summary a little further, it would not have allowed me to save some of the surprises in the film for the reader. Above all, Hitchcock pretends to surprise us; but in reality he toys with our expectations. His originality, or his audacity, actually consists in daring to reuse well-worn and traditional dramatic structures, although radically freshened—as much by his virtuosity as by subtle yet conclusive confusion of detail. I will explain by taking as an example the great bravura of the film—the "suspense" of the concert, where we await the crash of the cymbals (and the gunshot). Meanwhile, Doris Day, unaware of the prearranged signal, cries helplessly in the lobby of the

theater, and James Stewart escapes from the chapel.

As in the end of *Strangers on a Train,* although in my opinion in a much more brilliant fashion here, Hitchcock unabashedly utilizes parallel editing. This is the oldest of "suspense" methods, invented as we all know by Griffith for a famous episode in *Intolerance,* which has become the most naïve symbol of cinematic rhetoric. Its purely formal, mechanical effectiveness would seem to prohibit a shameless director from reusing it, except in genres that are themselves naïve, as in the Western, for example. But Hitchcock is the *only* director who *can* use it. As I said, he manages to posit the structure of the narrative itself as the subject of the film. Thus the most conventional method again becomes the best. The viewer no longer wonders what will happen—the conventions of the rhetoric guarantee it. He wonders how Hitchcock will get out of the situation. . . . I am not exaggerating. No matter how unsophisticated the viewer is in cinematic matters, he obviously is conniving with the director (the laughter in the theater proves it). The reality of Hitchcock's high level of mastery allows him to get just what he wants from the audience—Maurice Chevalier seduces the audience with a wink or a smile. But the filmmaker is only present through his art.

Therefore Hitchcock is justified in using connection through his parallel editing as it is used implicitly on a secondary level and also as a rhetorical symbol. But he does more than play his instruments with an ironic virtuosity that blots out all that we remember of the genre. He plays them with a supreme refinement of unforeseeable displacements. For example, the long sequence in the Albert Hall would normally end with the

arrival of James Stewart in the assassin's loge a fraction of a second before the cymbal crash. The so-called "parallel" editing is in fact a converging one. Two actions that are simultaneous yet separated in space must meet before the inevitable can occur. The good cowboy arrives, leaping from his horse just in time to save the young woman who is about to be raped by the bandit. Were he to arrive too late, the whole rhetorical process would appear absurd in retrospect. The anxiety imposed upon us can only be an optimistic one.

Surprising us with a tragic ending would not be up to Hitchcock's standards. His skill lies in inventing a third solution. It consists in shattering the long, slender point of the sheaf of convergence of the editing. Stewart arrives a little too late. The cymbals have already crashed. But Doris Day has seen the barrel of the gun and screamed—just in time to upset the assassin and deviate his shot. The prime minister is only slightly wounded. Besides, it is from this break in the point of "suspense" at the Albert Hall that the second "suspense" will come. The grateful prime minister invites our heroine to the embassy. I have dwelled here on only one example of Hitchcock's art. But I could find many others to illustrate clearly how he also uses a procedure that is just as classic in detective language—false leads. Have fun spotting them! I must also point out his art of discreet and ruthless caricature whose substance in this film is most often sociological. I will only cite two examples of this: the French police glimpsed at the beginning, and the choice of costumes once the action takes place in England.

For all these reasons *The Man Who Knew Too Much* seems to me more perfect in its genre than *To Catch a*

Thief and *The Trouble with Harry*. There are some who could consider it a minor film and I do not wish to inflate its ultimate importance. But for whoever wishes to grasp Hitchcock's art near the top of its perfection, *The Man Who Knew Too Much* will undoubtedly furnish a most exquisite illustration of cinematic genius.

(*L'Observateur*—October 18, 1956)

Hitchcock by Eric Rohmer and Claude Chabrol

W hen I was a kid, somewhere behind the Arc de Triomphe (was it de Wagram or de la Grande-Armée?) there was a store window which entranced me by its advertisements for ball bearings. There were extraordinary mechanical combinations in which the forces of friction were marvelously close to the void. A steel flywheel, once set in motion, activated by its kinetic energy alone, an incredible play of pulleys and belts on their drive shafts. This gorgeously useless gadget thus turned for days without any further human intervention. I still remember having seen another of these dark and magnificent steel machines whose move-

ment was maintained indefinitely by a drop of water falling every sixty seconds. But what impressed me most was a play of precision where at one end of the window one saw, falling on a sheet of polished metal, a steel ball that bounced off a series of other aptly placed sheets. At the end of these perfect hits the ball lodged itself in the narrow nook which inevitably awaited it.

I hope that Rohmer and Chabrol will take it as a compliment that their book on Hitchcock has irresistibly brought this nearly-forgotten recollection to mind.

After reading this fascinating book, I do not know if the perfection of the system—its micrometric precision related to the elegance and versatility of articulations as if to the inviolable toughness of the material—is due to the work they are analyzing or only due to their ideas. But one fact at least is certain, and that is that what I might call the intellectual, ideal, and real spectacle which they raise in our minds is surely equal to the best Hitchcock film.*

If one considers an ideal critic one who identifies his method with his object, and, reciprocally, who makes the subject enter the method, then this splendid

* I feel I must complete this article by quoting from a letter that Bazin sent me six months before his death: "I just finished my text on Orson Welles, which is eighty pages instead of the expected fifty, and this review of *Hitchcock* by Rohmer and Chabrol of which I am not proud. The best thing about it is that I quote profusely. This book is a small critical monument, a marvel of writing and composition. But who will notice it? It is a lost cause from the start. Hitchcock is considered a lesser light once and for all. *I* even believe he is. But the book by Rohmer and Chabrol is not. It approaches the sublime. Tell Rohmer this in case he believes that my review comes from the goodness of my heart. . . .

(Letter from Bazin to Truffaut—July 7 1958)

little book by Rohmer and Chabrol is not just a high point in film criticism but also surely one of the most important examples of art criticism in French literature in the last few years. Friendship and brotherhood cannot prevent me from saying this, all the more so because I do not agree with their admirable argument. But this is hardly important and I would be doubly thankful to them for revealing to me what I should like, if they were right.

But are they wrong? That is precisely what no one can prove without demolishing their argument on its own level. Under these conditions, they have nothing to fear. That is why I wouldn't dare, as I happily admire—in spite of the Hitchcock films I have not yet seen—the man they show me.

I have sought what might be the key to this faultless exhibition—the equivalent of the perfect roundness of the ball bearings. I believe it stems from Hitchcock's Platonism (actually from theirs). The analysis always manages to show us the directing as a pure impression in a theatrical reality. These authors elaborate on the basic idea with so much ingenuity that it transcends what is pertinent. Whatever the scenario or subject, Rohmer and Chabrol manage to find the dramatic theme and the moral idea that the film manifests. Their purpose in all this is, of course, to reveal some constants and some major themes, like that of the "exchange." Each scenario is merely a new variation on this. But the least hint of the dialectic on the part of the authors is not, however, intended to find, in this constant, something new and unforeseen which would only appear necessary and inevitable after the fact. They also give us the fascinating impression of a Hitchcock who is

always full of surprises and yet always, if not true to himself, faithful to his fundamental ideas. But I mentioned Platonism. It is best to use an example. Here is one on solitude taken from *Rear Window:*

... This idea is made concrete, on the one hand, by the photographer's inability to move from his wheelchair, and, on the other, by the group of well-separated rabbit hutches that are the apartments he can see from his window. Realistic, indeed caricatural, this latter motif provides an opportunity to paint several of the types of fauna flourishing in Greenwich Village in particular and a big city in general. A sealed world inside that other sealed world represented by the city, which can be seen through the gap of a narrow alley, it is made up of a given number of small, sealed worlds that differ from Leibniz's monads in that they have windows and, because of this, exist not as things in themselves but as pure representations. Everything happens as though they were the projections of the voyeur's thoughts—or desires; he will never be able to find in them more than he had put there, more than he hopes for or is waiting for. On the facing wall, separated from him by the space of the courtyard, the strange silhouettes are like so many shadows in a new version of Plato's cave. Turning his back to the true sun, the photographer loses the ability to look Being in the face. We risk this interpretation because it is supported by the ever-present Platonism in Hitchcock's work. As is true of Edgar Allan Poe's stories, this work is constructed on the implicit base of a philosophy of Ideas. Here, the idea—even if it be only the pure idea of Space, Time, or Desire—precedes existence and substance.

Rohmer and Chabrol always find and define the

moral theme which organizes the mise-en-scène. But even more abstractly than this expressible idea is what they successfully call, in the critique of *Strangers on a Train*, "The Number and the Figure." It is impossible to resist this dazzling exegesis, which is based on geometric themes: The line, symbolizing exchange or transfer, and the circle, which negates like the expression of solitude, egoism, and refusal. But I should quote the authors from the text:

As we have often pointed out, it is in the form that we must look for the depth of the work and that form is heavy with a latent metaphysic. It is therefore important to consider Hitchcock's work in the same way we would that of an esoteric painter or poet. The fact that the key to the system is not always in the lock, that the doors themselves are skillfully camouflaged, is no reason to insist that there is nothing inside.

We must follow through to the end; it is not enough to disclose a certain fetishism of situations and objects; we must also look for the relationship that unites these same situations or objects. We must go back to the purest essences of Figure and Number.

Let us therefore give substance to the idea of "exchange" in the form a refrain, something that comes and goes. Let us inscribe a circle over that straight line, trouble that inertia with a swirling movement. Suddenly our figure emerges, our reaction is released. There is not even one effect in *Strangers on a Train* that does not come from this matrix. The film begins with close-ups of steps, and these close-ups establish the rhythm and the tone. Hitchcock firmly returns to a discontinuous style: the confined space of a continuous decor cannot be allowed to contain the dominant rectilinear that

must here be extended as far as possible; the void separating the two men must be felt. But nonetheless space here is not less present, tangible, full—logically, if not actually. Then we find ourselves in the train, messenger of that implied continuity.

Two men are talking in a compartment: one, Guy (Farley Granger), is a champion tennis player; the other, Bruno (Robert Walker), represents himself as one of his fans. Bruno talks of the vertigo of modern life, of its intoxication and speed, and then he makes a proposal to Guy. He first explains that what makes a crime imperfect is the fact that the motive of its author can be discovered. He then suggests that they eliminate motives by an "exchange" of crimes; he will kill Guy's wife, who refuses to divorce him, and Guy will kill Bruno's father. Guy rejects Bruno's proposal, but because he cannot persuade his wife, a saleswoman in a "record" shop, to divorce him, he will be unable to marry the woman he loves—Ann, the daughter of a senator. As for Bruno, he decides to forge ahead.

He lies in wait for Guy's wife, who goes to an amusement park with two men. There, running into a child who is dressed as a cowboy and who playfully points his pistol at him, Bruno "bursts" the boy's "balloon" with a burning cigarette. Then the group embarks on a "lake" at the exit to the "labyrinth" of a "tunnel." A game of hide-and-seek follows: Bruno seizes the opportunity to strangle (in other words to "encircle" within his hands) the "round" throat of Guy's wife. The scene is filmed in the lenses of her "glasses," which have fallen to the ground. The murderer is then in a position to blackmail the tennis player, whom he keeps under a sort of "spell," making

him assume the responsibility for the crime from which he has profited. At every turn of the road he appears to Guy as his own image reflected in a mirror that scarcely distorts it, as Guy's evil *double*. (This phenomenon of possession once more evokes Dostoevski.)

But this perfect technician of crime is actually a psychopath. Strangling Guy's wife was as much a pleasure to him as an act of calculation. His hatred of his father, his attentiveness to his mother, his desire for destruction, for escape, his frenzied scheming, leave no doubt as to the Oedipal origin of his psychosis; it is the "roundness" and the "whiteness" of that throat which fascinated him. Like the teeth of Poe's Berenice, it is an idea. Bruno will rediscover that idea in the "round" throat and the "glasses" of the senator's younger daughter. It is she whom he will contemplate while pretending to play at strangling one of the women at a reception he has crashed. And through his skill in portraying transfers and substitutions of all kinds, Hitchcock masterfully makes us participate in the terror of the young girl who realizes that she is the object of the desire of which the other woman is the victim. Bruno, who has partially betrayed himself, decides to cover his tracks by placing at the scene of the crime a cigarette lighter he had taken from Guy when they first met on the train. This will give us a chase preceded by a tennis match (note once more the "exchange" and the "white ball").

Bruno loses precious time in retrieving the lighter, which has slipped down a sewer trap, while Guy manages to escape the surveillance of the detectives thanks to the complicity of Ann's sister, who has spilled her face powder ("white") over one of them. He will be able

to catch a "train" as the "disk" of the sun sinks on the horizon and Bruno, standing near the lake, awaits his turn at getting into a boat. For several moments, natural time substitutes for artificial suspense time, just as it did throughout *Rope*. Bruno, unmasked by the ticket-taker, has no other recourse but to jump onto a whirling "merry-go-round," which the owner unsuccessfully tries to stop. There is a savage struggle on the platform, which "turns" faster and faster while the children, thinking it a game, laugh. Hitchcock's cruelty is a new version of that in *Sabotage*. Finally the children understand; they are panic-stricken, and contrary to our expectations, their fears are borne out: the merry-go-round "bursts," comes apart, and sinks down amidst screams and the noise of breaking beams. Bruno is dead. Guy is saved and will savor in peace the fruit of another's crime.

Those who care to are free to insist that these different motifs of the straight line, the circle, the back-and-forth motion, the whirling movement, the number two, and the color white * are to be found in this film completely by chance. But in that case the same chance has to be used to explain their presence in some of Edgar Allan Poe's stories. That their introduction both here and in Poe is always deliberate is not certain, nor would it even be desirable. A great creator is like a good geometrist, in whom intuition precedes and

* This last motif is secondary, and besides it is purely contingent: White is the color of a tennis game. But Hitchcock (aided by Robert Burks, the cameraman) knew how to take advantage of the disquieting aspect of this white—milky and not bright—conceived as a positive and evil color and not as an absence, an emblem of purity.

guides reasoning. He makes his construction and leaves to scholiasts the burden of working out the sterile demonstration.

In this admirable exegesis we are able to appreciate what constitutes perhaps the most astonishing feat of Rohmer and Chabrol's book. Their work is essentially a critical thesis, perfect in its strictness of progression. Nonetheless they have managed not just to conserve this rigor but to give it, structurally and a priori, a descriptive and chronological form. Without ever deviating from the natural procedure of simply examining one film after another, they manage in each instance to furnish all the necessary biographical and filmographical information without being cumbersome. In addition to this, their account of each scenario and descriptions of the production and direction are both as honestly descriptive as possible while totally already frozen in the specific geometry of their thesis.

Do not think, from the relatively abstract analyses quoted here, that Rohmer and Chabrol's critical descriptions necessarily take an idealizing stance with respect to the subject of the film. There is no loss of concrete detail in the mise-en-scène. On the contrary. When it is necessary they admirably demonstrate the technique and concrete movement of a sequence. Here is an example of this in an examination of love scenes in *Notorious*:

The atmosphere of extreme sensuality that reigns in *Notorious* does not in any way clash with the abstraction of the style. In this film of close-ups, "matter"—admirably emphasized by Ted Tetzlaff's lighting (faces, metal, glass, jewels, rugs, floor tiles)—shines with a light that is alternately glacial or burning. In this plot

woven of reticences and lies, only actions count; but at the same time, the latter are a façade. There are two love scenes. The first, on the terrace, is only skin-deep. It is translated by a succession of oral contacts between two people glued to each other and to whom our eyes are glued. This thirst for kisses, which seems unquenchable, expresses the vanity of the flesh when love is absent. In the second scene the fleshly contact couldn't be more simple, but the feeling is real. When Devlin, come to save Alicia from death, steps from the shadows—in the same way he had appeared after the Miami drinking bout—and the camera, in a movement of extreme tenderness and sensuality, circles around the two lovers, the screen sparkles with an indescribable beauty, the secret of which Hitchcock learned from Murnau. Even the moments when the two protagonists are in the presence of a third party smolder with a hidden flame: when Devlin is surprised by the master of the house, he pretends to clasp Alicia in a falsely false embrace, but their feigned kiss is a real one.

This is how Rohmer and Chabrol enrich the crystalline edifice of their thesis, as if Hitchcock had only made the next film in order to surprise them as well as prove them right. They can modestly conclude that their author is "one of the greatest 'inventors of forms' in the whole history of film. Perhaps only Murnau and Eisenstein can, in this respect, stand up to being compared to him. Our task will not have been in vain if we have been able to show how, starting with this form, in terms of its strictness itself, a completely new moral universe was worked out. Here the form does not embellish the content. It creates it."

(*Cahiers du Cinéma*—September 1958)

6 Akira Kurosawa

Akira Kurosawa was born in Tokyo in 1910. He directed *The Legend of Judo* (1943); *Most Beautifully* (1944); *The Men Who Tread on the Tiger's Tail* (1945); *Those Who Make Tomorrow, No Regrets for Our Youth* (1946); *Wonderful Sunday* (1947); *Drunken Angel* (1948); *The Silent Duel, Mad Dog* (1949); *Scandal, Rashomon* (1950); *The Idiot* (1951); *Ikiru* (1952); *The Seven Samurai* (1954); *I Live in Fear* (1955); *Throne of Blood, The Lower Depths* (1957); *The Hidden Fortress* (1958); *The Bad Sleep Well* (1960); *The Bodyguard* (1961); *Sanjuro* (1962); *High and Low* (1963); *Redbeard* (1965); *Dodes'caden* (1970); and *Kagamusha* (1980). Kurosawa died in Tokyo in 1998.

The Lesson of
Japanese Cinema Style

The discovery of Japanese film is unquestionably the most important cinematic event since Italian neorealism. We are certainly discovering it very late. Moreover, this delay contradicts the premise that film is a widely and rapidly distributed art as opposed to traditional arts that only become meaningful after a lot of time has gone by. In fact, the cinema of Japan is much less known in the West than its painting or engraving. Closely linked with economic barometers, films are distributed on their readings. We learn that even before the war Japanese productions outnumbered those of Hollywood. The first adaptation of *The Pastoral Symphony* (Satsuo Yamamoto) was done there. It was almost entirely unknown. However, as early as 1937 and 1938

the Venice Biennial (politics substituting for economics at the time) accorded several hundred Europeans a glimpse of Oriental film. It was at still another film festival, Venice 1952, that *Rashomon* launched the opening up of the Western market. Since that time we have been able to admire an appreciable number of diversified works at festivals as well as at a few movie theaters.

I should remark in passing that whatever one might think about the official goings-on at the Cannes and Venice festivals, film history must give them credit for their noncommercial showings. We owe them not only important discoveries that would probably have been unavailable by usual distribution channels but, as a consequence, we have a different outlook on film history. For example, we cannot say for sure whether Italian neo-realism could have overcome the lack of enthusiasm evinced by its national audience and by its producers if the festivals hadn't assured it a smashing critical success abroad. Primed by the "financial pump" of exportation, Italian neo-realism little by little conquered its own market. The case was similar with Buñuel. Vanished, exiled, lost among the cheap melodramas of Mexican studios, Buñuel was reinstated by the 1952 Cannes Festival, to our amazement . . . and his. Sustained by international prestige, Buñuel has since been reintegrated into film history.

Admiration and Naïveté

But let me return to the Japanese. The beauty of their films reaches us with a delay, like that of light from

distant stars. It doesn't matter! What matters is that finally it *has* reached us. However, certain people are already gourmets and mock the naïveté of our admiration. And these same friends, using the excuse that they know a little Italian, do their utmost to convince us that we would be bored with neo-realism if we understood the dialogue. Last year at Cannes rumor had it that Kinugasa's *Gate of Hell* was nothing special and that the grand prize would go to Maurice Cloche's *La Porteuse de Pain.* "You know the Japanese don't like that film at all. For them it's a dreadful melodrama of an old worn-out story."

Nobility of the Melodrama

It just so happens that in the last few weeks we have seen what Japanese melodrama is: *The Golden Demon* (Eizo Tanaka, 1955) is really just a naturalistic melodrama, *Romeo and Juliet* reexamined by Octave Feuillet, French writer and playwright. But I would give nine out of ten of our "psychological" films for that particular melodrama. Actually our melodrama in the last century has lost almost all its dramatic integrity and merely survives as a parody. It is in Mexico, India, and in particular in Japan that melodramas still show up from time to time in their vivacious, sincere, and effective form. Were the same plot to be adapted in France, it would escape ridicule only because of its pseudo-psychological pretensions. What is admirable about *The Golden Demon* is that the richness and refinement of the setting and directing in no way excludes melodramatic naïveté.

But in the last analysis it is true that in spite of an equally polished mise-en-scène and perhaps an even more perfect color technique, *The Golden Demon* seems to be in a much lower class than *Gate of Hell,* which is confirmed retrospectively by the conviction of our admiration. If *Gate of Hell* is not *La Princesse de Clèves* * of Japanese film, or rather if the audiences in Tokyo or Nagasaki see a dozen like it every year, I think that this in no way diminishes the merits and interest of the film. On the contrary, in a singular manner it increases the merits and interest in Japanese film in general. It is a fortunate country where the most controversial films still appear in our eyes as miracles of balance and perfection.

However, it is time to introduce a very general critical problem about Japanese production, the solution of which could serve in many other instances. Sometimes we are amazed or irritated to learn that Americans admire *The Well Digger's Daughter* (1940) or *Sous le Ciel de Paris* (1951). Whatever minor qualities we can find in these films, it would be better if foreigners liked some of our other films, even those of Pagnol and Duvivier. I think that these differences of opinion cannot simply be explained by differences in national taste or by criteria generally acknowledged by the critics of a certain country. Jacques Doniol-Valcroze once published reviews by British critics of French films. We found that their opinions very rarely coincided with ours, but that our disagreements did not go so far as being contradictions. The misunderstanding I am re-

* A novel by Mme. de La Fayette (1634–93); published in 1678, it was extremely popular in its time.

ferring to is much more serious and can occur only among audiences who are widely separated by geography and mentality. It results from a very limited knowledge of the production in question. It can be summarized thus: what Americans admire about *The Well Digger's Daughter* is not the film or even Pagnol. It is the *freedom of the mise-en-scène in French film.* In the extreme, it is France itself they admire. And seen from this point of view they are not wrong. It is only when these common values have become familiar that the hierarchy between the works can be appreciated by the viewer. In other words, we are right in considering *Marius* (1931) or *The Baker's Wife* (1938) as masterpieces and despising *The Well Digger's Daughter.* But for an American who sees two French films a year these major differences are legitimately unimportant. What the American audience appreciates is not the artistic numerator of a particular film but the denominator common to all Pagnol's films, which actually defines their novelty. And, besides, don't we unknowingly often subject our historical admiration to the same dangers? Are we so sure that the Venus de Milo is one of the best examples of the sculpture of its time? But what we justifiably admire about it is a certain moment in Greek art.

Anonymous Craftsmen

Distance and perilous ways of distribution play the same role here as do the abuses of time. It is clear that we are hard pressed to discriminate in our admiration for such and such Japanese film between its specific

merits and those it shares with Japanese art in general. Must we renounce our pleasure and doubt its value because of this? Not at all. On the contrary, I see this as a confirmation of the exemplary merits of Japanese film. There are undoubtedly no other productions in the world that give us the feeling of being more perfectly homogeneous with the artistic spirit of a civilization. I've already seen some twenty or twenty-five Japanese films, diverse in genre and quite unequal in result. Between the sensitive and intimist neorealism of *Okasan* (Mikio Naruse), the baroque and sensual romanticism of *Beauty and the Bandits* (Keigo Kimura), the sumptuous and tragic ritual of *Gate of Hell,* by way of the naturalistic melodrama of *The Golden Demon,* the Parisian public itself already has some idea of this truth. But what I have not yet seen, even when the performance was boring, naïve, or, in my Western eyes, worthless, is a Japanese film that is vulgar or just in bad taste.

It is undoubtedly due to the evolution of Western art, its divorcement from the people, and its exacerbated individualization that any quality of anonymity has progressively disappeared since the eighteenth century. The style is that of the man; it is no longer that of civilization. We have great painters, great writers, and even great filmmakers. But we really have no great literature and, even less, great cinema. By this I mean no common style, no minimum language of which the most mediocre artist can blunderingly make use. The most admirable aspect of classical literature is not Racine or Madame de Sévigné but that so many of their contemporaries wrote like them. It is the modern prejudice of our authors that hides from us in Racine

the tremendous rhetorical groundwork from which his genius profited. Perhaps the cinema has gone through a primitive stage (or should we say "classical"?) in every country, the high point of its High Middle Ages. At that time, works were often anonymous. In any case, film existed as an entity in spite of the talents of its craftsmen. Today, perhaps only Hollywood still offers us—up to a certain point—the example of a cinema that is valuable not just in its individual works but also for the language of its "commercial" productions. There, the cinema is homogeneous to the civilization that it satisfies and expresses. But in Europe, the cinema no longer exists. There are only good and bad films, like books or paintings.

To elaborate further: in the most favorable cases our cinema endeavors to equal the traditional arts, usually novels or the theater. It manages to do so from time to time, but with difficulty. *Diary of a Country Priest* by Bresson is not inferior to Bernanos' book, but what about *Le Rouge et le Noir* (Claude Autant-Lara, 1954) or *The Pastoral Symphony*? We see that what is known as an "average film" implies the mobilization of less talent, taste, skill, culture, and creative will than, say, an average novel.

Yet it seems that Japanese films differ both from ours as well as from those of Hollywood. A country with an old culture and strong traditions, Japan seems to have assimilated film with the same ease that it used to assimilate all other Western technology. This technology did not destroy their culture but was immediately integrated into it, and the cinema was just as quickly and effortlessly attained on the level of Japanese art in general. When Castellani or Renoir use color more

tastefully and intelligently than their contemporaries, it is the result of their talent and culture.

The Style of a Civilization

In Japan, the opposite is undoubtedly true. It would be difficult to find a director so uncouth and unpolished that he would not spontaneously compose his shots according to the best plastic traditions of Oriental art. In the same vein, there is not one Japanese who could drop a cup of tea on a straw mat, nor, in the whole archipelago, is there a badly pruned cherry tree. And what I say about cherry trees and mise-en-scène is true, quite naturally, of their dramatic expressions. I see the true revelation of Japanese film in this amazing and unique lesson of style, not of the creative artist but of an entire civilization, which, to the last man, would not know how to violate the ritual of pain.

(*Arts*—March 9–15, 1955)

Rashomon

The quality, originality, and importance of a work like *Rashomon* are deeply disconcerting for criticism. Indeed it throws the viewer into an absolutely Oriental aesthetic universe. It does this, though, through a cinematic technique (photography and editing) which implies a solid and already ancient assimilation of the whole evolution of Western film, so that it completely enters a radically foreign system. Indian films are slow; Egyptian films are elementary and don't count. A series of psychological filters seems to come between us and the story they tell. These filters are not the same as material awkwardness but determine certain characteristics of the technique: shot length, slowness of the acting, simplicity in editing, lack of ellipse, and so forth. But one is certainly less alienated by the *technical* aspects of *Rashomon* than by those of a Soviet film, for example.

I tend to think that this phenomenon on the cinematic level is merely the result of Japan's particular evolution in the last fifty years (coinciding with the invention of filmmaking). We hear that the first Japanese films date from 1902. Our surprise in seeing *Rashomon* stems from the distant echoes of the Western world when faced with the 1905 Russian defeat and, more recently, Pearl Harbor. I mean to say that we are surprised by the Japanese ability to assimilate the technology of Western civilization and still retain an Oriental metaphysics, ethics, and psychology.

Be that as it may, the artfulness of the staging and directing in *Rashomon* implies not only technological *means* of the same caliber as those of Hollywood, for example, but total possession of the expressive resources of film. Editing, depth of field, framing, and camera movement serve the story with equal freedom and mastery.

And yet this story is specifically Japanese in subject matter if not in structure. The action takes place in the Middle Ages. A rich traveler and his wife are traveling through a forest when a thief ambushes them. He subdues the man, ties him to a tree, rapes his wife before his eyes, and then kills him. A woodcutter witnesses all this. But during the trial of the thief, captured a few days later, the three survivors of the scene—the thief, the woman, and the woodcutter—each tell a different version of the event. The film presents us with three successive versions, or rather four. With astounding boldness, the filmmaker also presents us with a version of the murder as told through a witch speaking in the dead man's voice. But nothing leads us to believe that the dead man's tale is more accurate than that of the

others. This apparently "Pirandellian" action also has a moral purpose: it serves to illustrate not so much the impossibility of knowing the truth through the human conscience as believing in the goodness of man. In each of these versions, one of the protagonists in the drama reveals an evil side. We can suppose that this radical phenomenon is fairly sincere once we know that *Rashomon*'s plot is based on a novel by Ryunosuche Acutagawa, who committed suicide in 1927.

I spoke of a mastery on a par with that of the most developed Western films. I did not say "identical." It so happens that certain aspects of the film are purely Japanese: first of all the action, as we have seen. Can we imagine an American or European script based on such an audacious situation as a wife being raped before her husband's eyes? Needless to say, no one is bothered by this boldness any more than by the obscenity of Phaedra's origins in *La Fille de Minos et de Pasiphaé: Minos' and Pasiphae's Daughter.*

The film is especially Japanese in the acting style. The influence of No theater is quite obvious. Yet the true problem, which only a specialist could resolve, would be how and in what way were the traditions of Japanese theatrical acting adapted to cinematic realism. But if the acting is always perceived as excessive, it is never exaggerated nor is it symbolic. In other words, the acting style is in the tragic vein (in which it evokes the masque) and yet it does not abandon psychological realism. It could not be more different from the exaggerated acting, reinforced by makeup, of the silent expressionist cinema. The actor is at the same time tragic and natural, perfectly integrated with the real set in which he performs. The basic problem of the tragic

style, which Western films could only resolve infrequently and uncertainly *(Nosferatu,* 1923; *The Passion of Joan of Arc; Les Dames du Bois de Boulogne,* 1944; *Hamlet)* is not in question here. It is resolved immediately.

In the same way there is no break or dissonance between the acting style and the cutting. If it were possible to justify that filmology is the concern of philologists and logicians, such a film would be a solid argument for it. Is film as a language SELF-encompassing as is human reason? We canot say that here the filmmaker is copying Western films or even that he is inspired by them. It would seem, rather, that he attains the same result through fundamental unity and universality of screen vocabulary, grammar, and style. A traveling shot is a traveling shot, be it Japanese, French, or American. But there is a certain rhythm, speed, and harmony between frame and camera movement. The traveling shots in *Rashomon* are therefore no more imported than the acting. There is an even more significant example relative to the use of sound: the tale of death is told through the words of a witch during a dance of possession. The oracle speaks with the dead man's voice, although strongly off-key and high-pitched. As could be expected, the effect is hallucinating. Such an original idea—Western films quickly lost interest in the expressionism of sound—implies a mastery of technology that is only equaled by the freedom with which it is used.

How does it happen that all these reasons for admiring this film do not, however, result in an unqualified approval? *Rashomon* implies the past and future existence of a solidly established production with skilled technicians, perfectly trained actors, a national

cinematic talent—in short, a situation much more comparable to that of England or France than to Mexico. Beneath our admiration and astonishment for such a work lies an uneasy feeling that we are perhaps being deceived. *Rashomon,* in its own way, is a serial film. Wouldn't we have the same feeling when seeing a good American film for the first time? At the one hundredth viewing we would discover that language is, in the last analysis, only language, and that a great film is something more. In a word, I suspect that hidden by the originality (relative to our ignorance) of *Rashomon,* there is a certain banality of perfection that limits my pleasure. This reservation is also a compliment. I have heard that Japan produces better films. I willingly believe it and would not be too surprised to learn that Akira Kurosawa is the Julian Duvivier of Japanese films.

<div align="center">(<i>L'Observateur</i>—April 24, 1952)</div>

The Seven Samurai

It is quite fashionable these days to be finicky when speaking of Japanese films, as well as to insinuate that their exoticism seduces the naïve among us, and that the Japanese critics are not wrong. Let us duly note in reporting the ratings given to Japanese films by Japanese critics, published in the outstanding issue of *Cinéma 55* (no. 6, June–July), that *Rashomon* was rated fifth in 1950; *Tales of Gengi* seventh in 1951; *Okasan* seventh, and *Life of O'Haru* ninth in 1952. *Ugetsu* was third in 1953 as was *The Seven Samurai* in 1954. It is thus worth noting that these titles were far behind many others that are totally unknown to us.

Should this decrease our enjoyment of these films in any way? Their exoticism and strangeness probably play a role in our admiration. I know for a fact that

Americans rated all Pagnol's films on the same level, whether good or bad. But first of all they are only half-wrong. Seen from that distance, from the wrong end of the opera glass, Pagnol looks like Pagnol. In the second place, European critics are now seeing more Japanese films than a big Hollywood director has seen French films. I have seen over two dozen. Of course, that is not very many, but is perhaps enough to permit me to discriminate among them.

Good Cinema

For five years I have been waiting for my admiration for Akira Kurosawa to wane, finally to expose my alleged naïveté of the preceding year, but each film festival strengthens the feeling that I am in the presence of everything that constitutes good cinema: the union of a highly developed civilization with a great theatrical tradition and a great tradition of plastic art.

The Seven Samurai might not be the very best Japanese production. There is undoubtedly more reason to prefer the tender lyricism and subtly musical poetry of a Mizoguchi (director of *The Life of O'Haru* and *Ugetsu Monogatari,* both 1952). Like *Rashomon, The Seven Samurai* exhibits a too facile assimilation of certain elements of Western aesthetics and their splendid blend with Japanese tradition. There is in this case a narrative structure of diabolical cleverness. Its progression is arranged with an intelligence which is all the more disconcerting because it respects the romantic approach and the progressive blossoming of a narrative that requires much time and labor.

Painting Humanity

All dubbings considered, *The Seven Samurai* is a kind of Japanese Western worthy of comparison to the most glorious examples of that genre produced in America, notably those of John Ford. However, mentioning this only gives an approximate idea of a film whose ambition and complexity go far beyond the dramatic framework of the Western. Not that *The Seven Samurai* is a complicated story in the sense that *Rashomon* is—on the contrary, the plot is as simple as can be. But this universal simplicity is enhanced by the delicacy of details, their historical realism, and their human truth.

To summarize the plot in a few words: a village, plundered every year by a gang of bandits, recruits seven samurai to protect it against the next attack. The forty bandits are destroyed one after another, even though they are armed with weapons that were almost unknown in sixteenth-century Japan. Four samurai are killed, but the villagers can once again plant their rice in peace. The beauty and cleverness of this story arise from a certain harmony between the simplicity of the plot and the wealth of details that slowly delineate it. Obviously this kind of narrative reminds one of Ford's *Stagecoach* (1939) and *Lost Patrol* (1934) but with a more romantic complexity and more volume and variety in the fresco.

As we see, these points of reference are very "Western." The same holds true for the content of the extremely Japanese images, where the depth of field is obviously reminiscent of the effects obtained by the much-lamented Gregg Toland. In conclusion I can't do better than quote Kurosawa's own declaration of faith: "An action film can only be an action film. But what a

wonderful thing if it can at the same time claim to depict humanity! This has always been my dream since the time I was an assistant. For the last ten years I have been wanting to reconsider historical drama from this new point of view."

(*France-Observateur*)

Ikiru

I wonder what was eating our friend Luc Moullet when he wrote that piece in the last issue of *Le Petit Journal* on the Kurosawa retrospective at the Cinémathèque française? As he was the only one to have attended the showings, no one can contradict him, especially since the director of *Rashomon* is overshadowed by unfavorable prejudice in *Cahiers du Cinéma*, which favors the tender and musical Mizoguchi. I will return to this contrast a little later on. For the moment I shall restrict myself to mentioning that this interesting initiative on the part of the Cinémathèque should have enabled us to sort out our thoughts on Kurosawa, presently known in France by only two films, *Rashomon* and *The Seven Samurai*.

It is basically true that both of these productions demonstrate an extremely skillful determination to be

Western. This preoccupation is very finely explained and analyzed in a remarkable little book by Shinobu and Marcel Giuglaris (7th Art Series). Akira Kurosawa, who belongs to a relatively young generation (he was born in 1910 whereas Mizoguchi recently died at the age of fifty-eight), is for all intents and purposes a postwar filmmaker. He is visibly very influenced by Western films dating from the thirties and forties and even more perhaps by American films than by neorealism. His admiration of John Ford, Fritz Lang, and Chaplin is quite evident. But this is not just a passive influence. It is not important merely to integrate this influence into his films; he intends to use it to reflect an image of Japanese tradition and culture that we can assimilate through our eyes and our intellect. He succeeded in doing this so well with *Rashomon* that one can say this film was what opened Western doors to Japanese cinema. But before him have come many other films, notably those of Mizoguchi, who has given us a production which is, if not more authentic, at least more distinctive and purer. Our ingratitude came easily as it was good form to reveal the snobbishness of the exotic in Japanese films. Kurosawa was therefore condemned for his wrong kind of exoticism and his concessions to the language of Western film. This was more visible still in *The Seven Samurai,* which was, on another level, a John Ford Western on a feudal theme.

I do not know if it was this ensemble of critical presumptions, which I share in part, that blinded Moullet when watching the films shown at the Cinémathèque. Still, for at least one of these films, I must give a radically different opinion.

Moullet calmly writes that *Ikiru* breaks the record

for the ridiculous. I find that it is perhaps the most beautiful, clever, and touching of any Japanese film I have seen, at least among the modern productions.

But I should emphasize first of all that this is a contemporary story and that the time element radically modifies the irritating problem of influences. Assuredly, and for a hundred real reasons, *Ikiru* is a specifically Japanese film. But what is striking and asserts itself in one's mind about this work is the universal value of its message. More precisely, *Ikiru* is Japanese as *M* (1931) is German or *Citizen Kane* American. There is no need for mental translation from one culture to another to read clearly the particular inspiration and the general meaning at the same time. The internationality of *Ikiru* is not geographic but geologic. It arises from the depths of the subterranean pool of morality where Kurosawa knew where to look for it. But as it is also a film about men of our time—contemporaries whom a short plane ride would enable us to meet face to face—Kurosawa is entitled to draw upon world cinematic language, as did James Joyce, who used the vocabulary of all languages to reinvent English—an English that we could call pre-translated and yet untranslatable.

And perhaps this is why, in 1952, *Ikiru* was rated number one on the list of the ten best national films by the Japanese critics, who we know have reservations about the samurai films sent to festivals and especially about *Rashomon.* Thus I wonder if instead of considering Kurosawa's cosmopolitanism as a commercial compromise, even if it is of a superior quality, we should not, on the contrary, consider it henceforth as a dialectic development showing the trend that Japanese cinema is taking. Perhaps I still prefer Mizoguchi's style, as it is the

pure Japanese music of his inspiration. But I surrender after seeing the abundance of intellectual, moral, and aesthetic perspectives opened by a film like *Ikiru,* which welds incomparably more important values into the scenario as well as into the content.

I will not dwell on Moullet's brief summary. After all, he no more betrays the film's subject than one normally would when it is taken out of context, out of its original conception. But I would like to point out that it concerns a kind of inversion on the Faustian theme. The old doctor wants to be young again, to live his life sinfully. The hero of *Ikiru* knows he is doomed but, in his few remaining months, he artlessly tries to experience a life he has unconsciously ignored. If he discovers that, as a civil servant, the easiest way is to do the good social deeds that fall within his realm, it is not because good tempts him more than evil but because a young and simple soul has shown him the meaning of the most humble action. Unwittingly this old man becomes a saint because it is his closest link to life.

We can imagine all the traps into which such a subject might fall: sentimentality, melodrama, moralizing, social reform. All these perils are more than avoided—they are transcended, and this is especially due to the wonderful handling of the narrative structure. What Moullet calls "the endless funeral," which does take up almost half the film, is an incredibly daring way of telling the story. For over an hour we see and hear the friends, relatives, and colleagues who attended the funeral. They speak of the deceased and drink rice wine and nibble on cakes. Of course, these conversations are intercut with flashbacks that gradually reveal the hero's activities before his death and, through them,

his true personality. But these backward glances are all fairly brief and in no way reduce the guests' discussions to a simple expedient. The film's subject matter is thus in the present as well as in the past. The narrative tension arises from the slowly emerging convergence between the secret truth of the evoked reality and the understanding that the characters eventually grasp. At the end of the film they finally understand the dead man's secret: he knew he was doomed and therefore sacrificed his last days to go on an exemplary mission. But by then everyone is drunk, and this truth is wasted on some worthy drunkards who will have forgotten it by tomorrow.

There are many other things one could say about *Ikiru,* especially on the subject that the element of time plays in the narrative—very different from Western dramatic requirements burdened by their artificial symmetry—yet there are no wasted moments. This way of seeing things is merely more skillful and delicate. But let's hope that some French distributor will soon be able to show this masterpiece to the general public and that we will thus be given a chance to reexamine it.

(*Cahiers du Cinéma*—March, 1957)